Fine Art Flower Photography

Creative Techniques and the Art of Observation

TONY SWEET

STACKPOLE
BOOKS

For Susan

Copyright © 2005 by Stackpole Books

Published by
STACKPOLE BOOKS
5067 Ritter Road
Mechanicsburg, PA 17055
www.stackpolebooks.com

Printed in China

10 9 8 7 6 5 4 3 2 1

First edition

Cover design by Caroline Stover

Library of Congress Cataloging in Publication Data

Sweet, Tony, 1949–
 Fine art flower photography : creative techniques and the art of observation / Tony Sweet.— 1st ed.
 p. cm.
 ISBN 0-8117-3181-2
 1. Photography of plants. 2. Flowers—Pictorial works. I. Title.
TR724.S93 2005
779'.343'092—dc22
 2004015396

Foreword

LOREN EISLEY, IN HIS CLASSIC BOOK *THE IMMENSE JOURNEY*, WROTE ABOUT THE evolution of flowers: "Flowers changed the face of the planet. Without them, the world we know—even man himself—would never have existed." Eisley was a scientist with the insight of a sensitive literary artist. His skill with words matched the intricate and diverse beauty of flowers, which has universally influenced humankind, including visual artists in all mediums. History clearly chronicles flowers in paintings, architectural inlays, frescoes, and cultural artifacts from around the world. Color photography may be a latecomer to the world of art, but its practitioners have embraced flowers as compositional favorites.

Tony Sweet's portfolio is a testament to the intrinsic, mystical qualities of flowering plants. Each visual interpretation draws you in like a bee to nectar. These seductive, abstract, and impressionistic images, imbued with color, deserve your quiet contemplation before you absorb the technical information. Tony's free-spirited and unrestrained approach to photography allows him to dissolve boundaries of traditionalism—a carryover, I'm convinced, from his experiences as an improvisational jazz musician.

This book is a garden feast. Each page blooms with the refreshing fragrance of creativity. Enjoy your visit!

Pat O'Hara

Prelude

THE BEAUTY AND INFINITE PATTERNS OF FLOWERS MAKE THEM A WONDERFUL subject for photographic interpretations. Flowers are among the first subjects that all new photographers seek. When I first got into photography, the first thing I did was head to the local nature center to find some flowers to photograph. Other photographers with whom I've spoken had the same initial response. Flowers are colorful, they don't move (except for an occasional breeze) and they don't mind being photographed. They are therefore an excellent way to learn about and experiment with lenses and filters, exposure, composition, and special photographic techniques and effects.

In my years as a photography instructor, I've noticed there is a discernable pattern and process when people begin photographing flowers. Initially, the flower is fully shown in harsh light against a busy background, with the flower dead-center or "bull's-eye" in the frame. These are problems that are easy to remedy. Once students see examples of more advanced compositional techniques and learn how to control light, they immediately start thinking outside of their "comfort zone" and begin the process of creating more technically sound images with more creative expression. In other words, they begin to develop a personal style.

Many of the flowers in this book are unnamed. There are two schools of thought as to naming subjects. The first is to record the subject accurately with regards to name, genus, species, etc., which is necessary for stock images and editorial work. The second is to approach the subject with an open mind and view it as a series of lines, shapes, angles, and textures—to photograph the subject from a more emotional perspective. The latter is how I approach all subject material. It enables me to continually view familar subjects in new and different ways.

The images in this book are designed to illustrate different ways of seeing an all-too-familiar subject along with some advanced compositional techniques. It is my hope that this book will open up your creativity and lead to a more personal and unique approach to the wonderful and endless world of flower photography.

Tony Sweet

The camera always points both ways. In expressing your subject,
you also express yourself.

—Freeman Patterson

Daffodils and Wind

Patterson Park, Baltimore, Maryland

Nikkor 80–200mm f/2.8 lens
81B multi-coated warming filter
f/22

It is not common practice to photograph flowers when it's windy. Normally, we want these pictures sharp, which requires small apertures, and therefore longer shutter speeds, for the greatest depth of field. That is certainly one way to do it. Another way would be to use the wind to create a softer, more impressionistic look. With gently blowing flowers, consider using the smallest aperture for the longest possible exposure in order to record movement rather than sharpness. Depending on the movement, between one-quarter and two seconds of exposure is an average time for this effect.

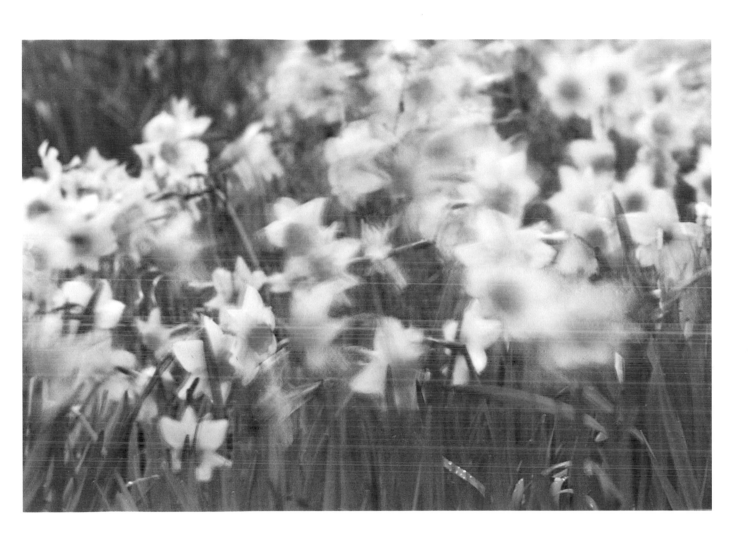

Impatiens Under Sheet Web

Brookside Gardens, Wheaton, Maryland

Micro-Nikkor 105mm f/2.8 lens
Tiffen 812 filter
f/22

I always look for sheet webs—spiderwebs on the ground—with colorful subjects under them. The resulting effect is a textured one, not unlike photographing through a screen or other translucent, textured overlay. The yellow centers were all cropped out except for the two placed in the middle of the frame, and the camera was turned slightly to juxtapose them diagonally. One of my most frequently used filters is the Tiffen 812, a mild red intensifying filter that slightly pumps up the red, leaving other tonalities largely unaffected. Compositionally, the red petals act as a secondary frame, or a frame within a frame, drawing attention further into the yellow centers.

Single Lupin and Dewdrop

Shamper's Bluff, New Brunswick, Canada

Micro-Nikkor 105mm f/2.8 lens
81B multi-coated warming filter
f/2.8

Shooting close-ups wide open with selective focus is an easy way to achieve "moody" flower images. Here, I used the wide-open aperture and focused on the lupin in front of the dewdrop to create the large, out-of-focus orb in the background, resembling a sun that is low on the horizon. The coloration of the dewdrop comes from the reflected color of the dusk sky. Bright, out-of-focus highlights take on the shape of the lens diaphragm (in this case, wide open), thus the roundness of the dewdrop. If shot at f/16, the dewdrop would take on the shape of that lens diaphragm, appearing hexagonal in nature.

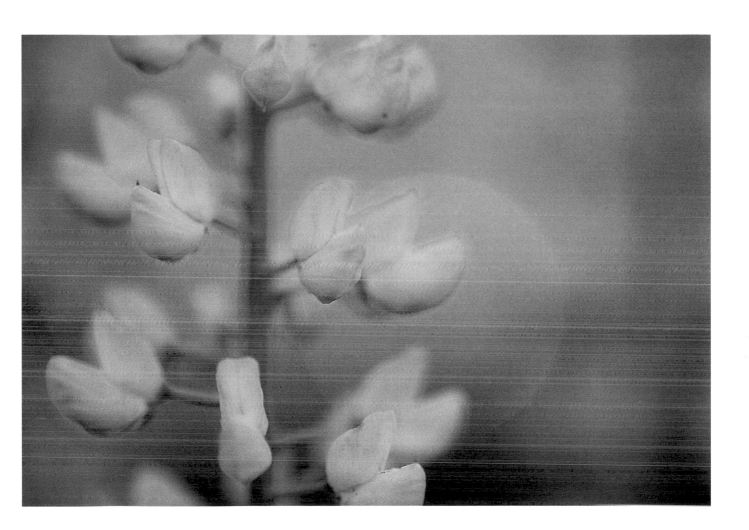

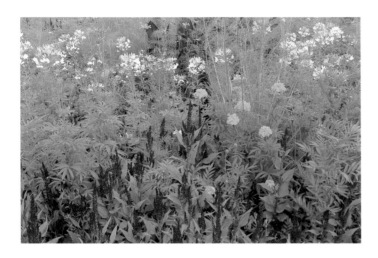

Garden Abstract I

Sherwood Gardens, Baltimore, Maryland

Nikkor 35–70mm f/2.8 lens
81B multi-coated warming filter
f/8
Multiple exposures with upward movement

The juxtaposition of these two images illustrates the multiple exposure effect. The many colors in this small patch of flowers were the attraction and made great grist for the multiple exposure technique. I made eight exposures while moving the camera upward in very small increments between each shot, keeping the movement in as straight a line as possible; this created the "colored pencil" look. Shooting at f/8 rather than f/16 gives a less sharp, more impressionistic appearance. Notice how there is visual activity throughout the picture and how the red creates a frame and visual weight at the bottom of the image. When using creative techniques, it is important to pick an appropriate subject, which is determined in part through experience.

Instructions:

1. Set your camera up to shoot eight or nine exposures on a single frame at −3, that is to say, each exposure is three stops underexposed. This can be done manually or on aperture priority using exposure compensation at −3. The number of exposures can depend on your brand of camera. For example, Nikon SLRs easily allow for eight exposures, while Canon SLRs allow up to nine.

2. Take the first exposure, then move the camera slightly upward in as straight a line as possible.

3. Repeat for the remaining exposures.

4. Don't forget to advance the film and take your camera off of multiple exposure mode and exposure compensation after making your multiples. Otherwise, everything that you shoot afterwards will be on one piece of film and three stops underexposed!

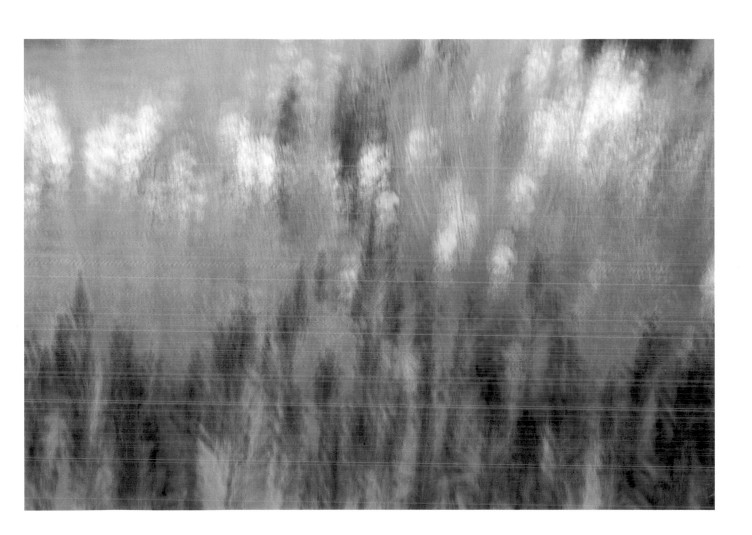

Triangles

Sherwood Gardens, Baltimore, Maryland

Nikkor 85mm tilt/shift f/2.8 lens
81B multi-coated warming filter
f/22

The alternating color bands (triangles) were the reason for taking this image. I selected the 85mm tilt/shift lens because of its focal length. This is a small area and a shorter, wide-angle lens could not isolate this pattern. However, telephoto lenses are not the right tool for images where depth of field is important. That's where the tilt/shift properties of this lens come into play: the film plane can be adjusted to create great depth of field with a lens not inherently capable of doing so. It was important to get the proper balance of the colors, with the purple (the darker color) bottom-weighting the image and fully enclosing the two yellow wedges.

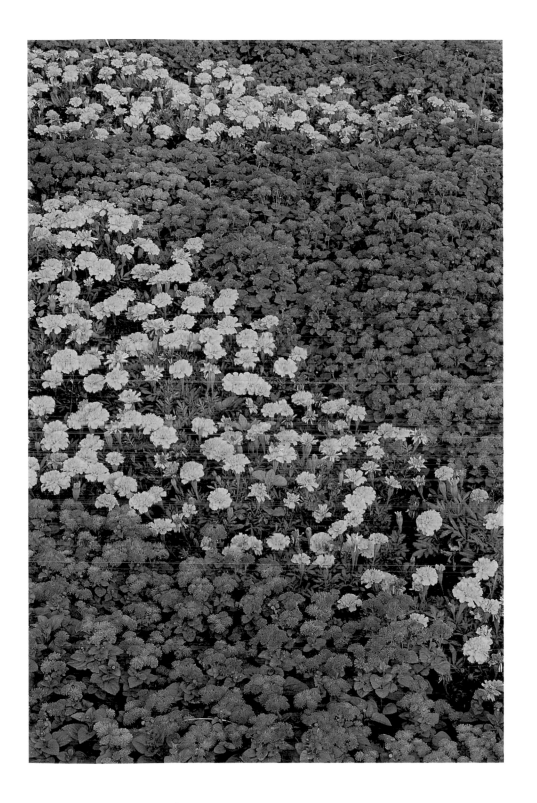

Soft Dwarf Iris

Great Smoky Mountains National Park, Tennessee

Nikkor 105mm f/2.8 lens
81B multi-coated warming filter
f/2.8

I noticed tall green grasses on a distant hill behind these flowers. Getting down to eye level with the subject brought in the muted background color of the grass along with two very out-of-focus dwarf irises. The shallow depth of field and selective focus on the very tip of the foreground iris created an almost surreal muted color scheme. There doesn't need to be very much in sharp focus for an image to work, but with limited depth of field the issue becomes where to direct your point of focus for maximum visual impact. It's a good practice to bracket the point of focus when shooting at your minimum depth of field. In the sea of green and purple, I chose the small color area at the very tip of the first flower. The white with the dark purple outline and the yellow center is enough to stand out and attract the viewer's interest.

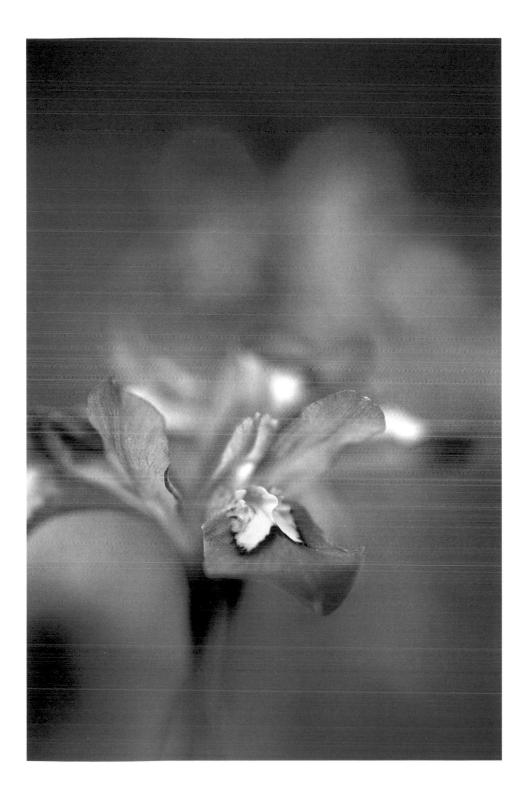

Dominance

National Arboretum, Washington, D.C.

Nikkor 300mm f/4 lens w/27.5mm extension tube
81B multi-coated warming filter
f/4

This is quite simply a picture of a beautiful, marbled background of various flowers, all blended together as a result of using a long lens and a shallow depth of field. I took care to find a foreground subject where the background flowers were all several feet behind the point of focus, which was instrumental in creating the evenly toned and textured background. The red salvia is shown slightly off to the side in order to give the viewer's eyes something upon which to rest. This illustrates the "pull" of red for the human eye: even this small bit dominates the frame and our attention.

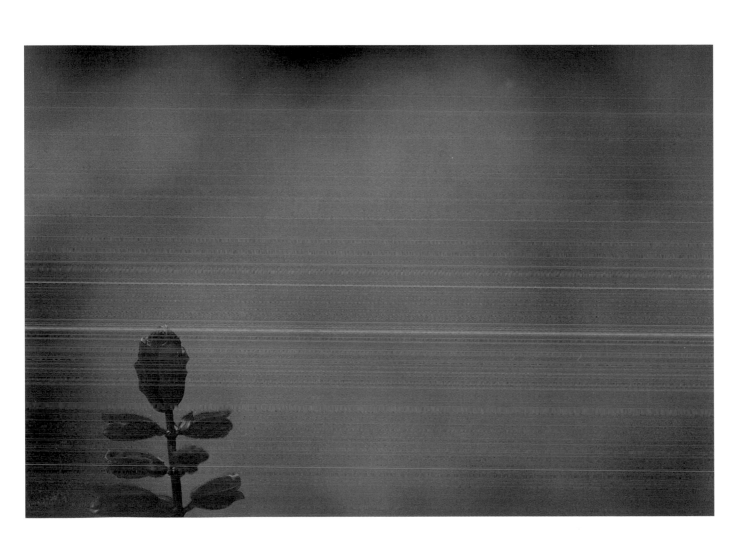

Great photography is about depth of feeling, not depth of field.
—Peter Adams

Flower and Backlit Dew

Sherwood Gardens, Baltimore, Maryland

Nikkor 300mm f/4 lens
81B multi-coated warming filter
f/4

Under normal conditions, photographing flowers in bright sunlight without a diffusion disk is a big problem because of the harsh highlights and black, detail-less shadows created by the high-contrast light. What caught my attention here was the spiderweb between the lens and the flower. The round highlights are a function of focusing past the dewy spiderweb to the rose. Only bright sun back-lighting a subject can create this effect. Because this image was shot wide open, the bright highlights became round orbs floating in the frame, just as all strongly lit specular highlights take on the shape of the lens diaphragm. The sun in this image was at a 45-degree angle and I had to shield the lens with my hand to avoid lens flare. Using a hat as a shield also works well.

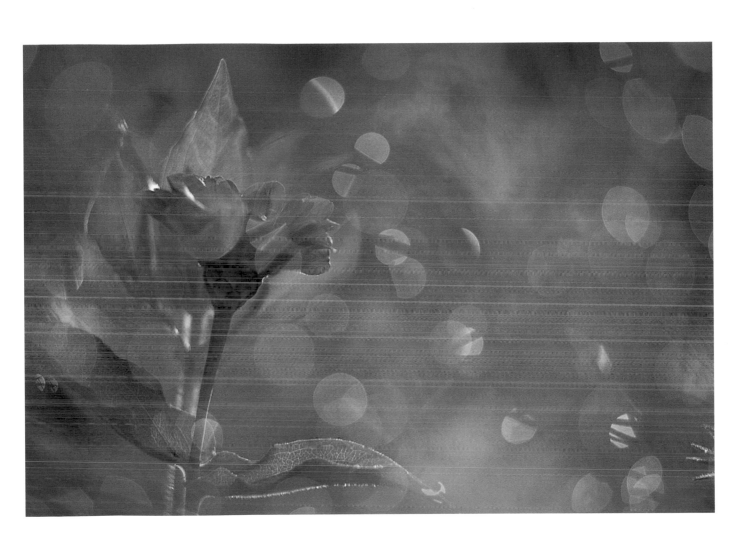

Tulip and Highlight

Sherwood Gardens, Baltimore, Maryland

Micro-Nikkor 105mm f/2.8 lens
81B multi-coated warming filter
Gold/silver reflector disk (gold side)
f/8

The strong backlighting on this image would normally be a big distraction, to the point that I would not have taken the photograph. A couple of elements changed my mind. The tulip is large enough in the frame that it is more prominent than the bright light. Since the light is behind the tulip, I used a gold reflector to add light to the flower, giving it prominence in the frame. Also, the highlight cutting across the frame acts to separate and accentuate the tulip instead of overpowering it. Notice that the discernable edges of the highlight area have some "corners" to it. As shown earlier, bright highlights take on the shape of the lens diaphragm. Shooting wide open yields round highlights; any other f-stop will show edges, as seen here.

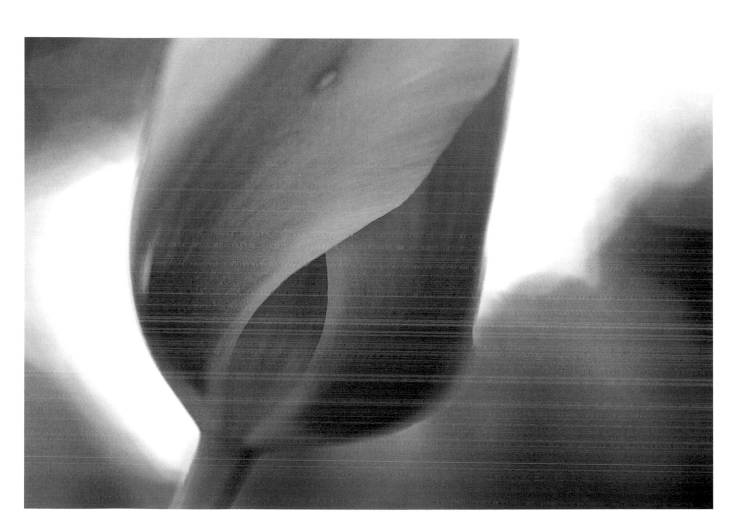

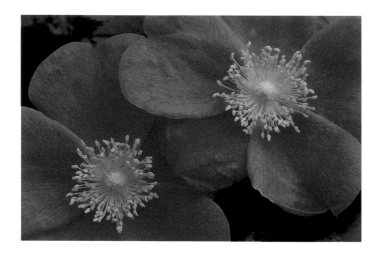

Two Rugosa

Indian Harbor, Nova Scotia

Micro-Nikkor 105mm f/2.8 lens
81B multi-coated warming filter
Slide sandwich/montage

The slide sandwich is a technique in which two separate images are made at different exposures and placed together in a single slide mount. As you can see, the final image has a "glow" or halo effect that is indicative of this particular technique. This is a high-contrast technique and should be made in diffused light or on a bright, overcast day, avoiding shadows as much as possible. For best results, use a telephoto lens in the 80–200 range and shoot a scene with average tonality.

Instructions:

1. Make the first image at f/22 and overexpose by two stops. This can be done manually or on aperture priority using exposure compensation at +2.

2. Make the second image at your widest aperture, overexpose by one stop, and defocus until the image blurs. The defocusing, in combination with the sharp +2 overexposure in Step 1, is what creates the appearance of a glow.

3. When you get the slides processed, unmount the two sandwich slides and remount them together in a GEPE glassless slide mount, Art. no. 7001.

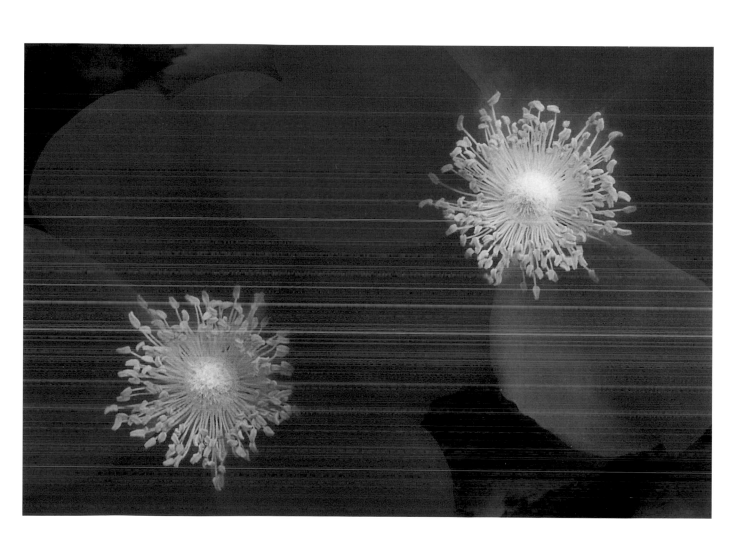

Single Water Lily

Brookside Gardens, Wheaton, Maryland

Nikkor 80–200mm f/2.8 lens
81B multi-coated warming filter
Nikon polarizing filter
f/22

It is very unusual to find pristine water lilies and supporting leaves. There is almost always something starting to decay, or else parts of the scene are being destroyed by bugs. So, being there at the right time is crucial. Visiting gardens several days in a row during peak time is recommended; July and August are the best months in most conservatories and arboretums for water lilies and lotus blossoms. Because the subject in this picture was in the shade, the 81B popped the amber tonality of the flower and the polarizer removed the glare from the leaves. I placed the flower off-center, framed within the three shaded areas.

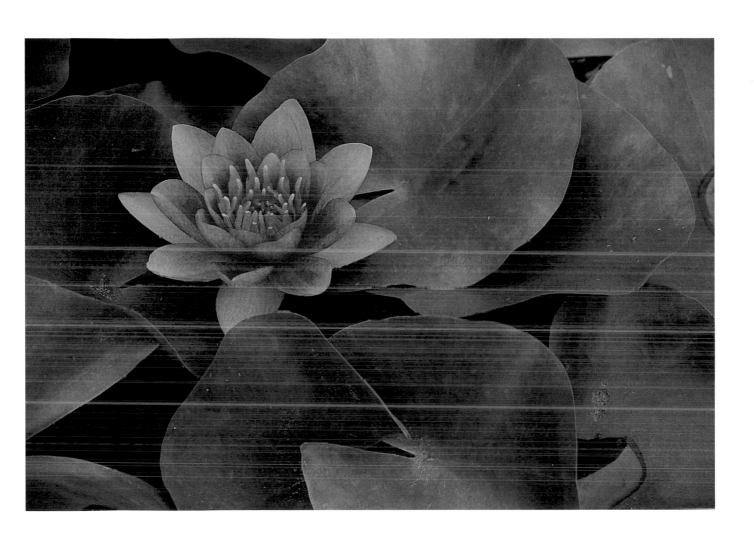

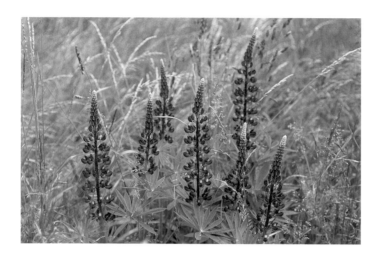

Lupin Patch

Acadia National Park, Maine

Nikkor 80–200mm f/2.8 lens
81B multi-coated warming filter
f/22
Multiple exposures with zoom

This is a multiple-exposure image. I zoomed in slightly before each of the eight exposures, refocusing on the top of the center lupin. I had been looking for a clean area with just a small patch of lupin and grasses—no twigs, leaves, or any other extraneous material. This way, the "zoom lines" were unbroken and appeared to be exploding from the center of the image.

Instructions:

1. Set your camera up to shoot eight or nine exposures, three stops underexposed, on a single frame. This can be done manually or on aperture priority using exposure compensation at –3.

2. Take the first exposure, then zoom in slightly.

3. Repeat for the remaining exposures, refocusing on the same central point each time.

4. Advance the film and take your camera off of multiple exposure mode and exposure compensation after making your multiples.

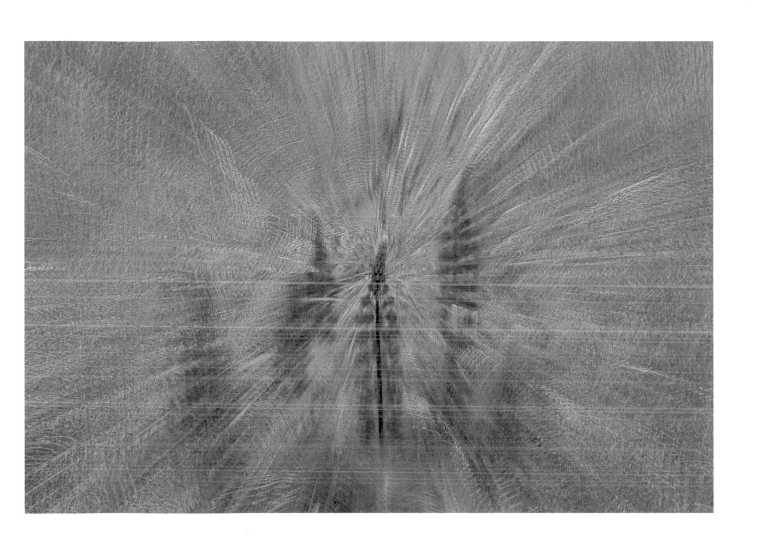

Salvia Abstract

Brookside Gardens, Wheaton, Maryland

Micro-Nikkor 105mm f/2.8 lens
Singh Ray red intensifying filter
f/4

I was so blown away by the color in this scene that I wanted as little sharpness as possible in order to preserve the blending of the red, yellow, and green tonalities. Too much sharpness would lose the painterly effect. I chose just one point of focus for a visual anchor: the very tip of the frontmost salvia. The lens was very close to the tip of the stamen, while the distance between the tip and the background salvia and rudabeckia was great enough that I was able to stop down one stop for a little extra sharpness without bringing in any additional background detail. Thus, I placed the sharpest part of the image, which is red, against the green background for maximum impact.

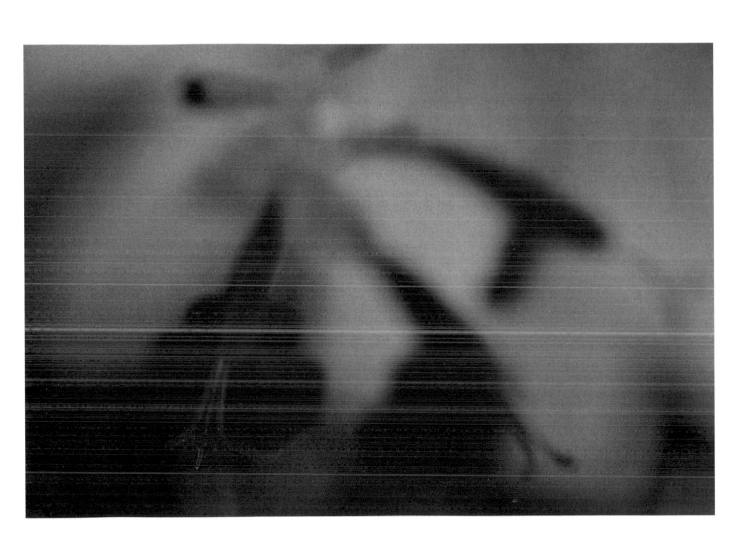

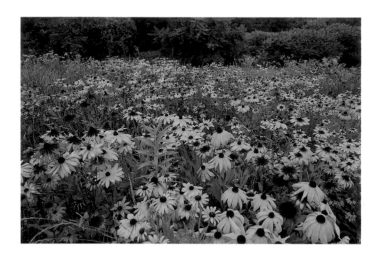

Spring Wildflowers

Cylburn Park, Baltimore, Maryland

Nikkor 35–70mm f/2.8 lens
81B multi-coated warming filter
Slide sandwich/montage

This is another slide sandwich in which two separate images are made at different exposures and placed together in a single slide mount. The main image is slightly recomposed. As before, there is a glowing effect, the result of the two-stop overexposure. Remember, this is a high-contrast technique and should be made in diffused light or on a bright, overcast day, avoiding shadows as much as possible. For best results, use a telephoto lens in the 80–200 range and photograph a scene of average tonality.

Instructions:

1. Make the first image at f/22 and overexpose by two stops. This can be done manually or on aperture priority using exposure compensation at +2.

2. Make the second image at your widest aperture, overexpose by one stop, and defocus until the image blurs. The defocusing, in combination with the sharp +2 overexposure in Step 1, is what creates the appearance of a glow.

3. When you get the slides processed, unmount the two sandwich slides and remount them together in a GEPE glassless slide mount, Art. no. 7001.

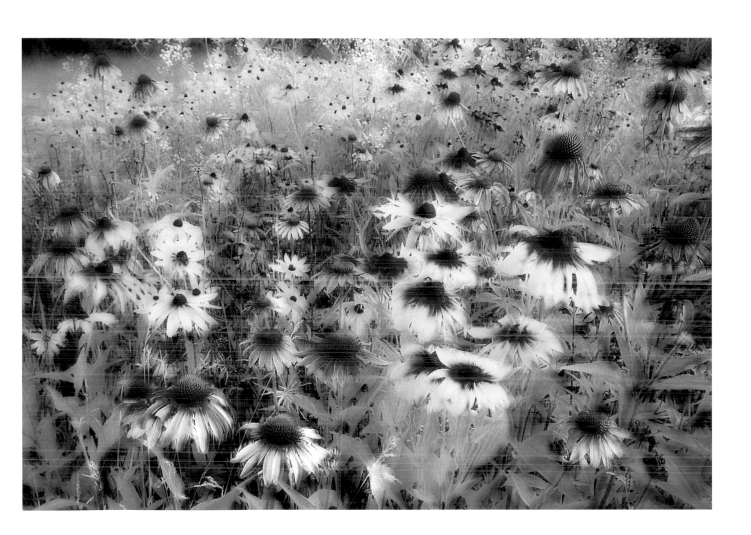

Pink Tulips and Purple Flowers

Longwood Gardens, Kennett Square, Pennsylvania

Nikkor 300mm f/4 lens
Singh Ray diffusion filter
81B multi-coated warming filter
f/5.6

For this image, the camera was positioned to take advantage of the soft back-light on the tulips. The shallow depth of field blends the purple, green, and pink background tonalities. It was important to separate the foreground tulips in the front left and the background tulips at the top right. I always strive for separation between elements. If any flowers from the two groups touched or merged, the image wouldn't work. In this case, the foreground flowers also frame the background group. The diffusion filter, which softens and brightens the image, also gives a light and uplifting feeling to the scene.

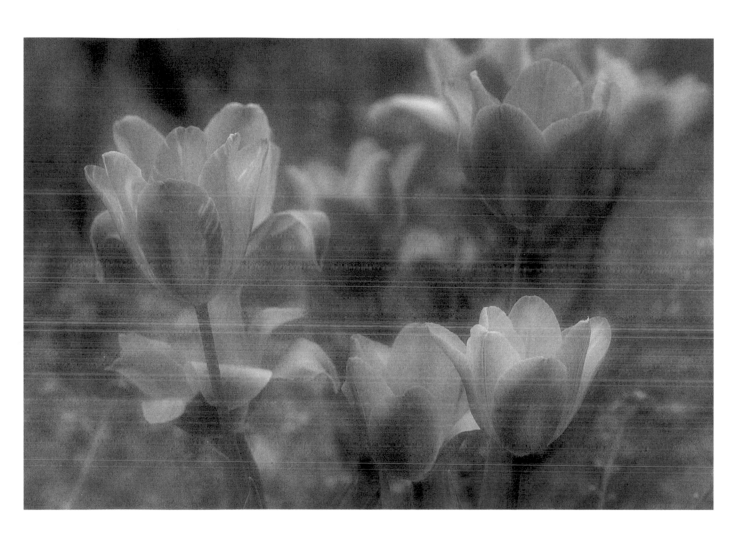

The hardest thing in photography is to create a simple image.
 —Anne Geddes

Tulip and Azaleas

Sherwood Gardens, Baltimore, Maryland

Micro-Nikkor 105mm f/2.8 lens
81B multi-coated warming filter
f/4

As you will see throughout this book, I actively seek out detail-less pastel
backgrounds that further draw attention to the subject. In this image, the goal
was to create a very clean and simple graphic. The purple background is a col-
orful patch of azalea that is two feet behind the subject. Placing the 105mm
very close to the tulip and using a shallow depth of field caused the quick
fall-off of the background and, therefore, the soft, seamless, muted color.
I decided to focus on the green stem to heighten the contrast between it and
the reddish background. Focusing on the stem at this minimal depth of field
caused the tulip bulb to go out of focus and become an almost perfect white.
I had to move the camera slightly to disclose the backlight accent at the bot-
tom left and right of the bulb, just above the stem.

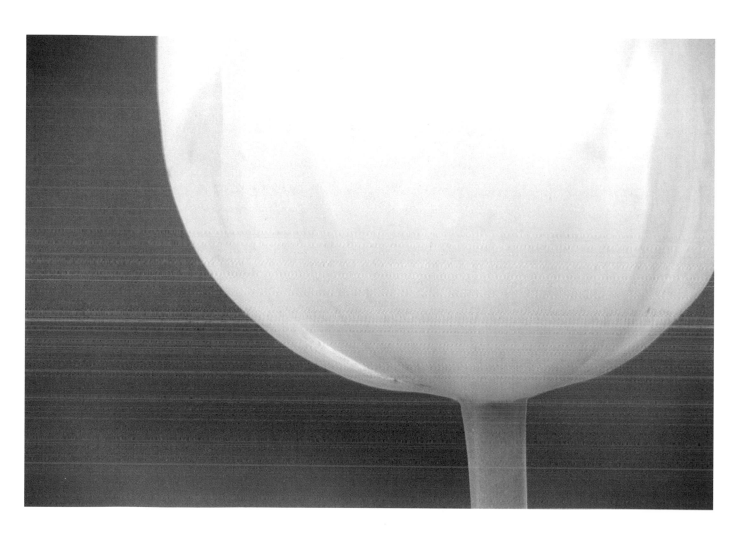

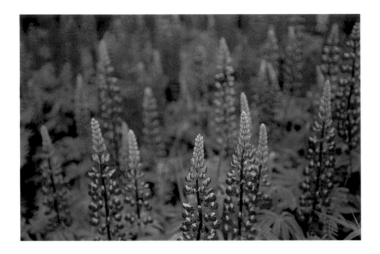

Lupin Cones

Acadia National Park, Bar Harbor, Maine

Nikkor 35–70mm f/2.8 lens
81B multi-coated warming filter
f/8
Multiple exposures with vertical movement

The juxtapositon of the "before" (above) and "after" (facing page) images shows the multiple-exposure effect on this image, which was created by moving a handheld camera in short up-and-down movements between each exposure. The blending of the blue and the pale green is remarkable in the multiple version, which combines eight exposures. Since one cannot duplicate the movement in handheld multiples, each image is unique. Therefore, it is a good idea to photograph at least five versions of a multiple exposure subject. I shot ten of this one with what felt like the same movement and wound up keeping only two. The shallow depth of field and small movements created the painterly appearance. It's always a good practice to fill the frame with the subject, texture, or pattern you are shooting whenever appropriate.

Instructions:

1. Set your camera up to shoot eight or nine exposures, three stops underexposed, on a single frame. This can be done manually or on aperture priority using exposure compensation at –3.

2. Take the first exposure, then move the camera slightly up or down.

3. Repeat for the remaining exposures, moving the camera a short distance after each shot.

4. Advance the film and take your camera off of multiple exposure mode and exposure compensation after making your multiples.

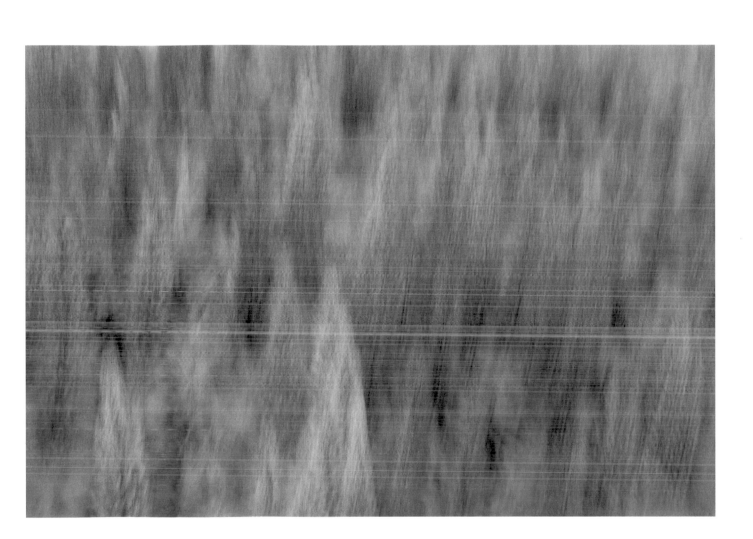

Vision is the art of seeing things invisible.
 —Jonathan Swift

Colorful Swirl

Sherwood Gardens, Baltimore, Maryland

Nikkor 35–70 f/2.8 lens
81B multi-coated warming filter
f/16
Multiple exposures with zoom and rotation

The attraction here was the bold colors of these flowers. The small patch of orange flowers acted as the "hub" around which to rotate and zoom for each of the nine exposures. Even when using special techniques, thoughtful composition is most important. The orange flowers are placed in the lower right third of the frame, and the movement emanates from there, also.

Instructions:

1. Set your camera up to shoot eight or nine exposures, three stops underexposed, on a single frame.

2. An architectural grid screen is suggested for image placement for this technique. (In general, it is also recommended for keeping your horizon lines straight for landscape photography.) Take the first exposure, then rotate the camera slightly to the right or left. Zoom in a small bit, keeping your "hub" in a predetermined grid intersection on your grid screen.

3. Repeat for the remaining exposures, repositioning the target flower in your grid each time.

4. Advance the film and take your camera off of multiple exposure mode and exposure compensation.

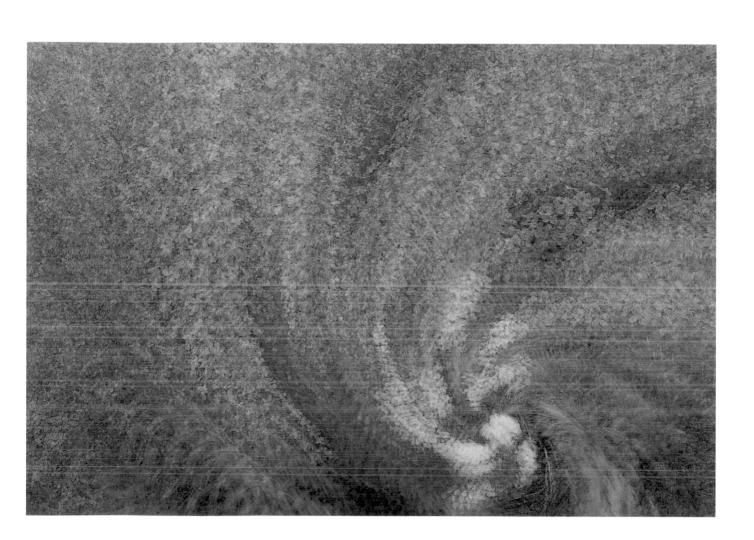

Red Cosmos and Bud

Olney, Maryland

Nikkor 80–200mm f/2.8 lens
Singh Ray red intensifying filter
f/5.6

Because they are opposite colors and create the greatest color contrast, photographing red against green is a great way to get color to pop. Notice how the edges of the red have an almost three-dimensional appearance. The muted background, including the two completely soft orbs at the top, is a function of the shallow depth of field. I try to include as much color as possible in a color photograph. The camera was angled upwards in order to include the blue tonality (the sky). The background was far enough behind the foreground poppy that I was able to stop down for a little extra sharpness and completely bring in the flower center. One composition issue was whether to bend back (not break off) the bud or include it. I decided to include it for two reasons. First, because it occupies an important area in the picture space, which would appear too vacant without it. Second, because it helps tell a story of growth, from bud to flower.

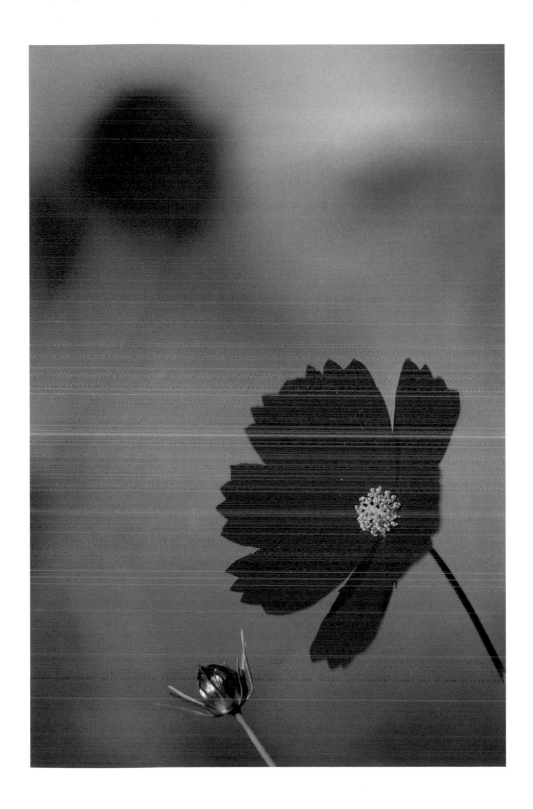

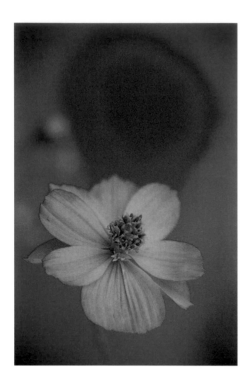

Coreopsis and Cosmos

Sherwood Gardens, Baltimore, Maryland

Nikkor 300mm f/4 lens w/14mm extension tube
81B multi-coated warming filter
f/4
Triple exposure

The image on the right is the triple exposure. All three exposures were shot wide open at f/4. The first exposure (shown above) focused on the center of the foreground coreopsis; the shallow depth of field caused a halo to form around the cosmos and softened up the background. The second exposure focused on the center of the cosmos and was also shot wide open, causing a halo to form around the coreopsis and blurring out the background further. The third exposure was completely defocused, which eliminated nearly all extraneous elements, and thereby showed the two flowers in a sea of detail-less green. The exposure compensation for a double exposure should be –1; for four exposures it should be –2. For triple exposures, the compensation should be between –1.3 and –1.7.

Instructions:

1. Set your camera up to shoot three exposures on a single frame. Exposure compensation should be between –1.3 and –1.7, depending on the tonality of the scene and how accurately you want to render it.

2. Shoot the three exposures wide open, with the camera in the same position each time. Each exposure should be focused on a different element in the frame, though you may want to shoot one completely defocused.

3. Advance the film and take your camera off of multiple exposure mode and exposure compensation after making your multiples.

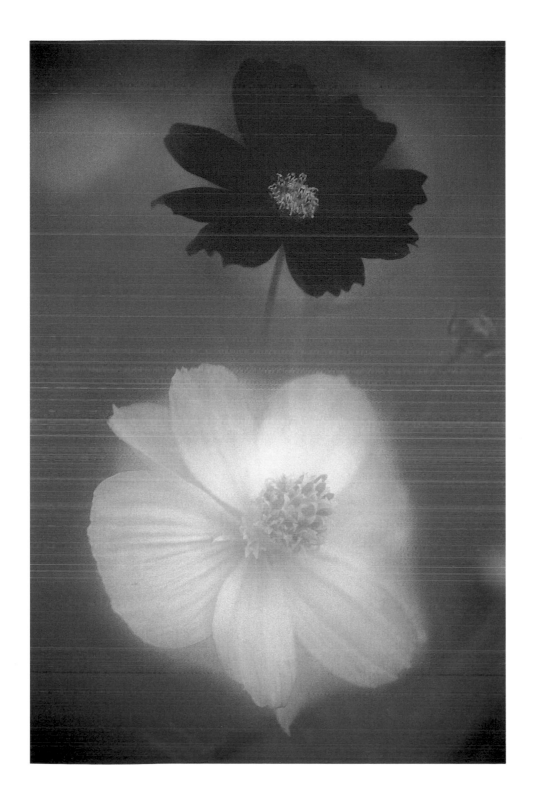

Solo Red

Wildflower patch, Baltimore, Maryland

Nikkor 80–200mm f/2.8 lens w/27.5mm extension tube
81B multi-coated warming filter
f/5.6

One of the most striking aspects of this image is the subtle, out-of-focus background, a function of the distance between the red flower in the foreground and the sunflowers and bright green grasses in the background. The most important thing to me in shooting this picture was to get the center of the foreground flower as sharp as possible. The distance between the subject and the background enabled me to stop down two stops to f/5.6 for greater sharpness without affecting the muted detail in the background. Placing the red off-center and in the green area increased color contrast and intensified the red, further drawing the viewer's attention to the yellow center. Also worthy of note is the color repetition between the yellow center and the yellow muted background, which helped to unify the image elements.

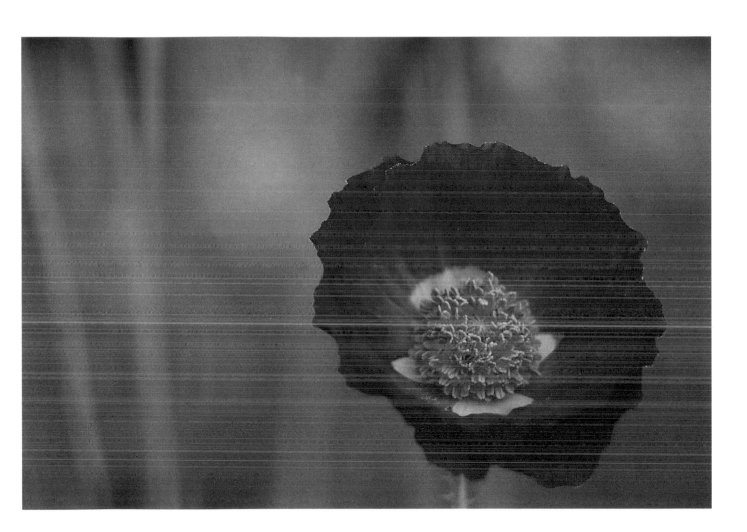

Yellow in Red

Longwood Gardens, Kennett Square, Pennsylvania

Micro-Nikkor 105mm f/2.8 lens
81C multi-coated warming filter
f/32

Placing a subject in the center of the frame usually yields a static composition. A perfectly symmetrical and pristine subject, such as this fresh, full-frame flower center, is an exception. In order to show the center graphic most effectively, I placed the camera close enough to fill the frame with the red petals. I used the smallest aperture for maximum depth of field and therefore the longest exposure. Because of the long exposure, I searched for a subject that was a bit recessed and away from direct air and wind. Therefore, it was in fairly dark shade, necessitating the use of the 81C warming filter to remove the blue cast that occurs in deep shade and maintain the vibrant color of the petals and stamen.

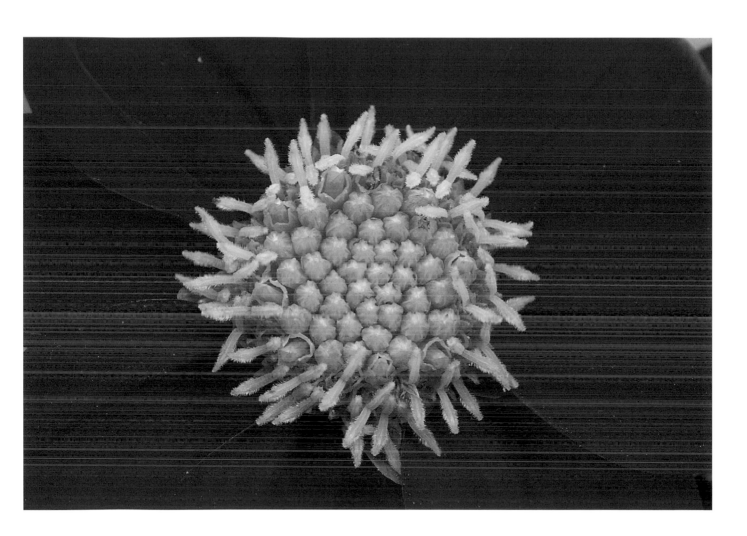

Salvia and Soft Rudabeckia

Brookside Gardens, Wheaton, Maryland

Nikkor 80–200mm f/2.8 lens w/27.5mm extension tube
Singh Ray red intensifying filter
f/4.0

In this picture I framed the red salvia in the green crevice between the rud-abeckia, which accentuated the red—green and red are opposite colors and create the highest color contrast. This is why the red appears to jump off of the page. Several rudabeckia are actually in front of the salvia, but the shallow depth of field with the focus on the salvia creates visual disorientation with respect to these yellow areas, further riveting the attention of the viewer on the red. The Singh Ray red intensifying filter was used both to enhance the red and to deepen the yellow.

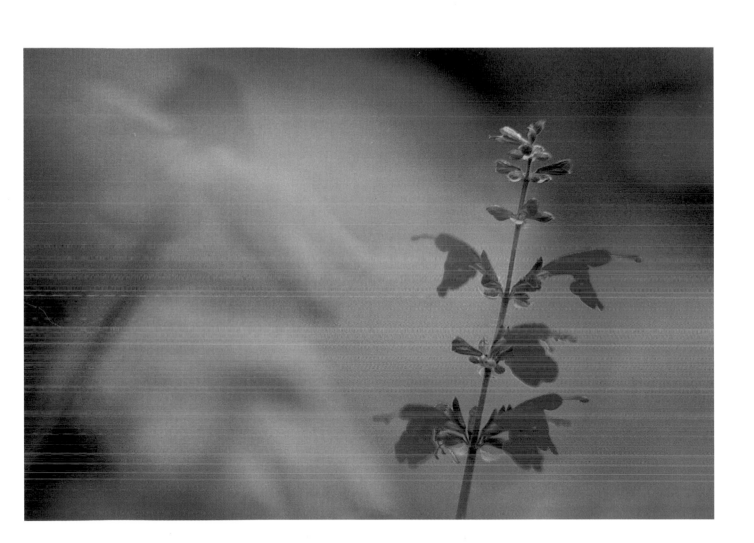

Trust that little voice in your head that says, "Wouldn't it be interesting if . . ."
And then do it.

—Duane Michaels

Wind

Sherwood Gardens, Baltimore, Maryland

Nikkor 80–200mm f/2.8 lens w/27.5mm extension tube
81B multi-coated warming filter
f/8
Multiple exposures with moving subject

Every so often, the wind is such that a flower just won't be still, and we can use that to our advantage. This image combines eight exposures that were made while the flower was quivering. The movement was subtle enough that the exposures were all fairly similar, hence the tight look and the relatively sharp center of the flower. F-stop was an important consideration: if it had been at f/16 or f/22, the exposure time would have been longer and the exposures would all be blurred together. Also, f/16 or f/22 would have rendered the background flowers much sharper and the soft effect of the background would have been lost. I used f/8 to limit the motion through the shorter exposure time and to create the soft background.

Instructions:

1. Set your camera up to shoot eight or nine exposures, three stops underexposed, on a single frame. This can be done manually or on aperture priority using exposure compensation at –3.

2. Make your exposures as the subject is gently swaying.

3. Advance the film and take your camera off of multiple exposure mode and exposure compensation after making your multiples.

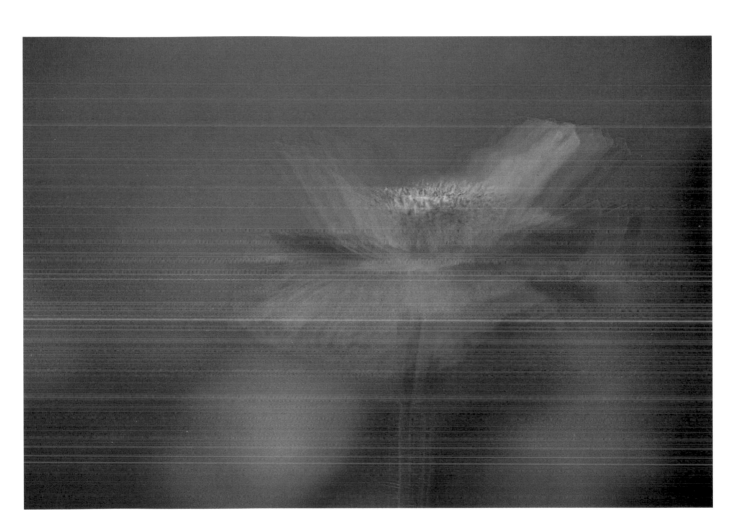

Edge

Baltimore, Maryland

Micro-Nikkor 105mm f/2.8 lens
Nikon 3T close-up diopter
Tiffen 812 mild red enhancing filter
f/2.8

There are numerous wildflower patches planted by many states in spring and summer, one of which provided the subject for this picture. This image is quite simply a picture of a red line that happens to be on a poppy. I used the widest aperture and the most shallow depth of field to blend and blur the background colors while carefully focusing on the red edge. Except for the front edge, all of the elements of the image are soft, pastel supporting tonalities that are completely free of detail. It was somewhat breezy when I took this picture, but bright enough that my shutter speed enabled hand-holding of the camera. I just postioned myself, waiting for the breeze to pause for a fraction of a second.

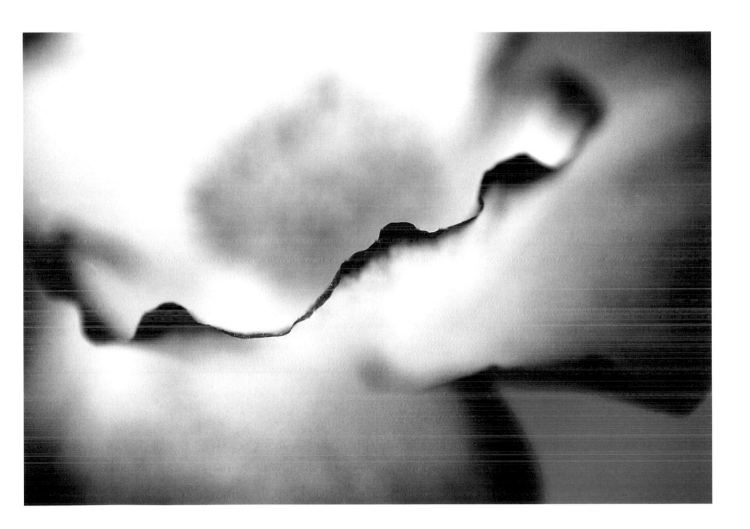

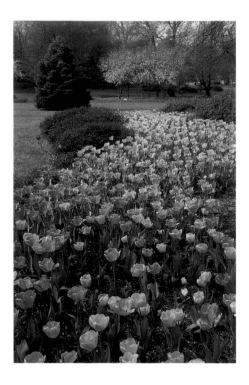

Tulip Multiple

Sherwood Gardens, Baltimore, Maryland

Nikkor 35–70mm f/2.8 lens
81B multi-coated warming filter
f/22
Multiple exposures with vertical movement

As with some of the other photographs, this image was created by moving a handheld camera in short up-and-down movements between each exposure. Notice how the basic graphic elements are still intact, despite the camera movement—the line leading to the background tree is still pronounced. This is achieved by making the movements during each exposure very small, maintaining the graphic integrity of the image. Note that the white sky and the dark holes in the foreground, visible in the smaller image, are covered by the multiple movements.

Instructions:

1. Set your camera up to shoot eight or nine exposures, three stops underexposed, on a single frame. This can be done manually or on aperture priority using exposure compensation at –3.

2. Take the first exposure, then move the camera slightly up or down.

3. Repeat for the remaining exposures, moving the camera a short distance after each shot.

4. Advance the film and take your camera off of multiple exposure mode and exposure compensation after making your multiples.

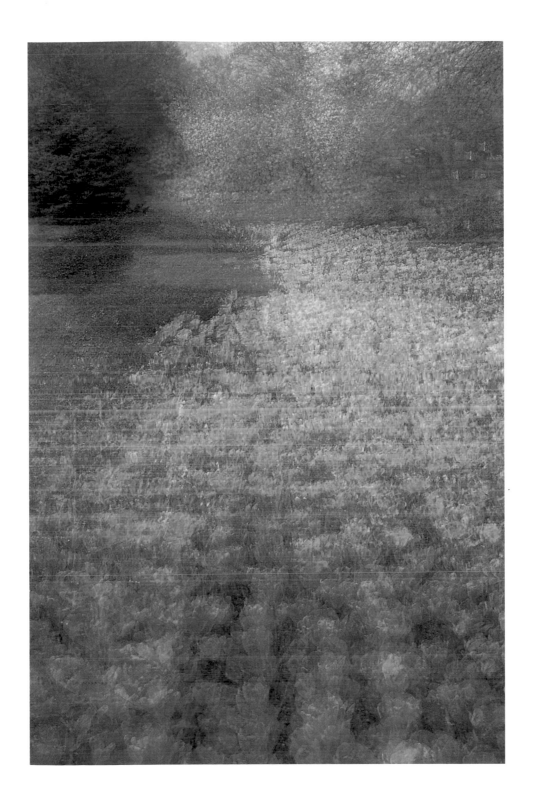

Orchid and Single Dewdrop

Longwood Gardens, Kennett Square, Pennsylvania

Nikkor 105mm f/2.8 lens
81B multi-coated warming filter
f/22

Bright images such as this one are referred to as "high-key." This one is white and bright yellow, which evokes a light, uplifting feeling. The white in the top left and bottom right balances and frames the yellow perspective lines flowing from the center and the single water drop at the bottom left. Despite an aperture of f/22, the image is not completely sharp. As magnification becomes greater, depth of field becomes much less apparent, even at the higher f-stops.

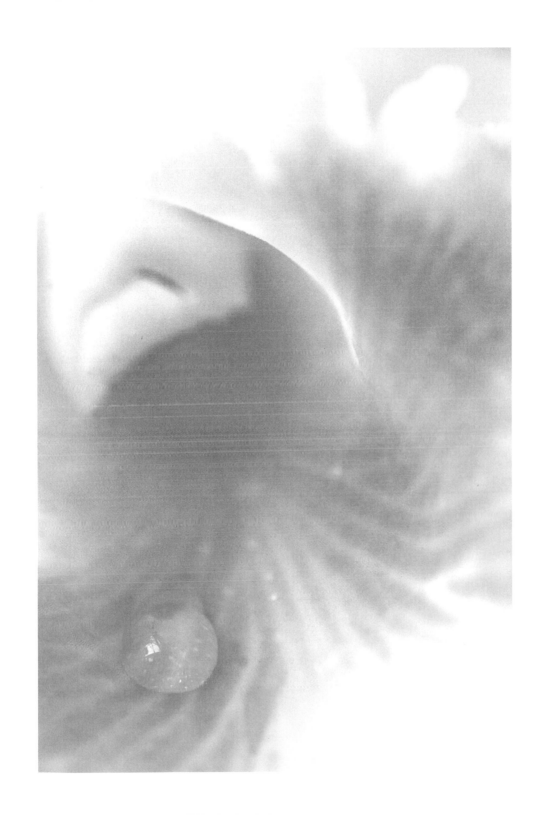

Narcissus

Longwood Gardens, Kennett Square, Pennsylvania

Micro-Nikkor 105mm f/2.8 lens
81B multi-coated warming filter
f/11

The amount of color in this image is remarkable. All the colors are pristine, including the blue, detail-less background, which is water moving in a fountain. The distance between the subject and background was important here, as I was able to stop down sufficiently to sharpen the flowers without showing the ripples in the background water. Notice the balance at the edges of the frame: the elements are not touching the edges, are more or less equidistant from the top and sides, and are a bit bottom-weighted.

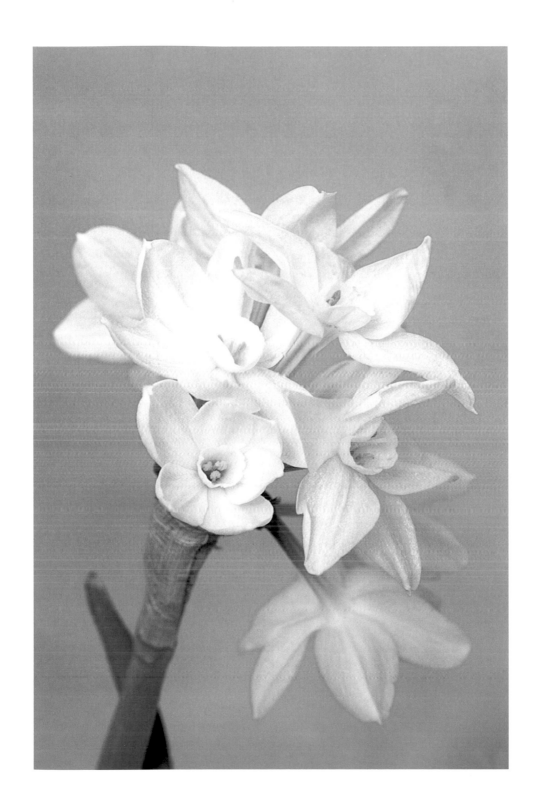

Rose

Longwood Gardens, Kennett Square, Pennsylvania

Nikkor 105mm f/2.8 lens
81B multi-coated warming filter
f/16

The rolling shape of this rose's petals makes the flower an excellent candidate for a full-frame rendering. Because I was shooting into an area with dark shadows, and remembering that the Fuji Velvia ISO50 I was using was high-contrast film, I was careful to eliminate as many dark areas as possible while maintaining the image's flow, which is from top left to bottom right. My first inclination might be to "spritz" this subject—to spray water on it with an atomizer. But, sometimes the spritzing doesn't bead up in a photogenic fashion and the subject is ruined. It's a good practice to photograph your subject before altering it. In this case, the dry version rendered better than the spritzed version.

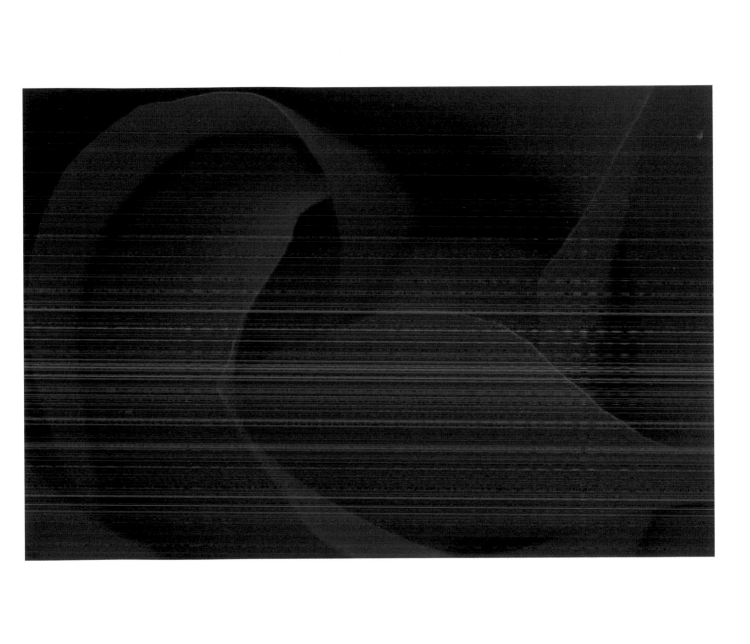

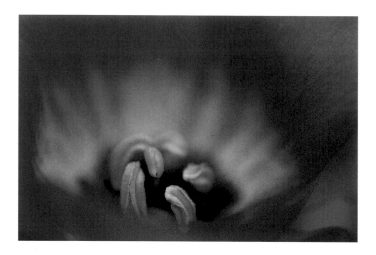

Spiral Graphic

Brookside Gardens, Wheaton, Maryland

Nikkor 85mm tilt/shift f/2.8 lens w/27.5mm extension tube
1.4x teleconverter
Canon 500D close-up diopter
81B multi-coated warming filter
f/45

The small image at the top is the more impressionistic scene of the two. It was photographed with a 105mm f/2.8 macro lens up against the petal edge at f/4 to create a soft, pastel appearance.

The main image of the same subject at the right is noteworthy for its pristine detail. This type of pristineness is usually fleeting and should be shot immediately. Just visit a garden several days in a row when flowers are blooming and subjects should present themselves. In a complicated and extensive setup like this, the image is only as sharp as the weakest link in your equipment. The tilt/shift lens was used because this image was photographed at an angle—I was able to alter the plane of focus and increase sharpness throughout the frame. With a normal macro lens, shooting at an angle, even at f/32, would not achieve this sharpness.

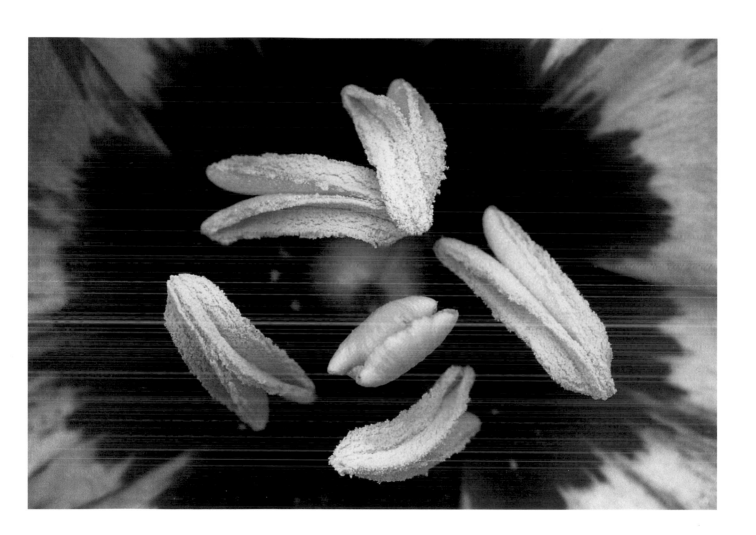

Seeing the smallest dewdrop, you can stand in awe of perfection.

—John Shaw

Flower Portrait in Dewdrop

Sherwood Gardens, Baltimore, Maryland

Micro-Nikkor 105mm f/2.8 lens w/27.5mm extension tube
1.4x teleconverter
Nikon 4T close-up diopter
81B multi-coated warming filter
f/16

Flowers reflected in dewdrops are a favorite subject of photographers. Luckily, this drop was isolated, and the background impatiens were far enough behind that I was able to stop down to f/16. This depth of field enabled me to sharpen the blade of grass, the dewdrop edge, and the flower reflected in the dewdrop without bringing in detail in the background. In "macro-land," at high magnification, there is a lot of depth in a dewdrop, and getting the entire orb and the inside detail sharp without affecting the background is a rare occurence. This image is clean and sharp because I used all top-quality glass: the lens, teleconverter, diopter, and multi-coated warming filter are all "top drawer."

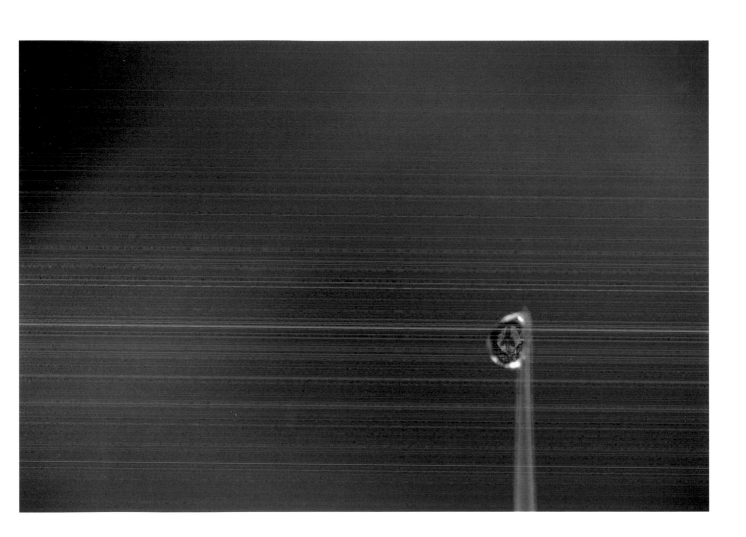

Dewdrops on Petunia Leaf

Sherwood Gardens, Baltimore, Maryland

Nikkor 85mm tilt/shift f/2.8 lens w/12.5mm extension tube
1.4 teleconverter
Canon 500D close up diopter
81B multi-coated warming filter
f/45

This is a classic use of the tilt/shift lens. The petal is highly magnified and photographed at an angle. There is about two and a half inches' distance between the foreground tip of the petal and the drop at the very top and back of the image. This is a great distance in macro-land! No conventional lens can give you this level of sharpness, at this angle and magnification, throughout the image plane. Notice the balance throughout the image: the right and left ends of the petal are equidistant from the edge of the frame, and the image is weighted toward the bottom. The shape of this image is designed to take the viewer in circular fashion, from the top water drop, following the brightest areas of the image down the left side to the tip at the bottom right, then up the right side to the starting point.

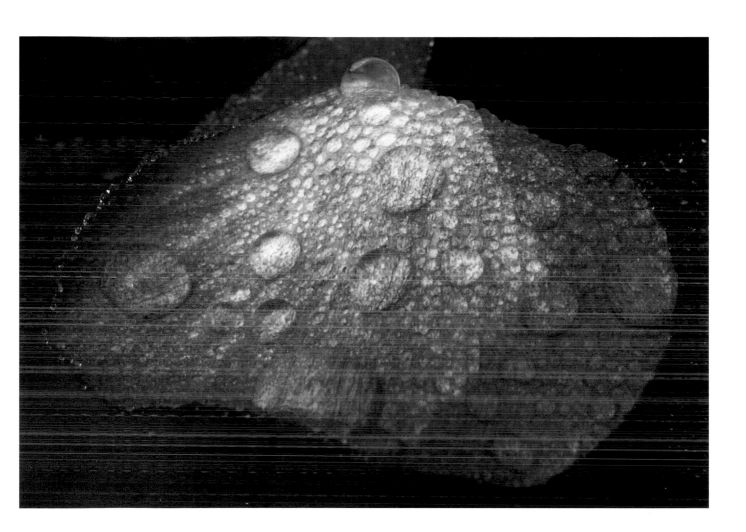

Lotus Blossom Repetition

Brookside Gardens, Wheaton, Maryland

Nikkor 80–200mm f/2.8 lens w/27.5mm extension tube
81B multi-coated warming filter
f/22

This subject is amazingly pristine—this is the peak moment for these lotuses.
Within in a day, or maybe even hours or minutes, insects can take hold, a cold
night can cause decay, or rain can damage the petals and the centers. As John
Shaw says, "Shoot it when you see it." On an overcast day, with diffuse light,
it's still important where we position the camera. The inner glow of the centers
is a function of repositioning the camera at an angle where the soft, diffuse
light brightens them. Compostionally, the lotuses cut a diagonal line through
the frame. The petals of the flowers are dramatically cut off—to just cut off
the tips would be a visual distraction and weak composition. Even though this
is shot at f/22, the magnification and the nature of telephoto lenses cannot
fully bring the background lotus center into sharp focus, which is exactly the
desired effect. The eye goes back and forth, but always returns to the bottom
left, the sharpest and brightest portion of the image.

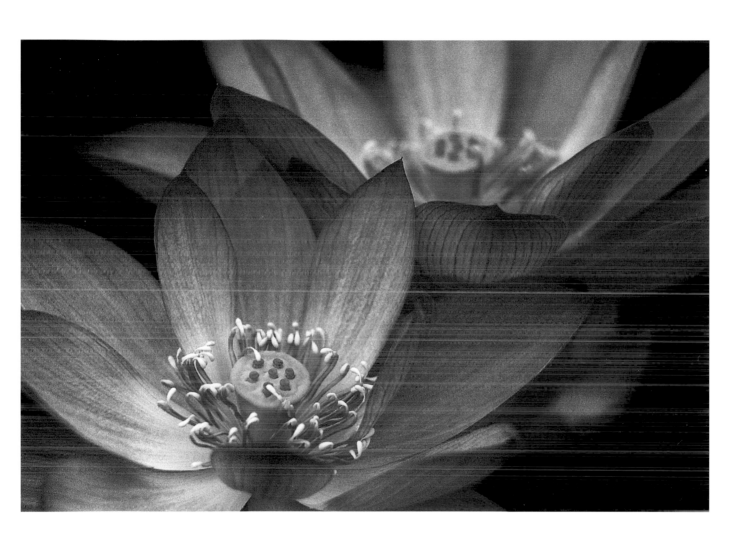

Colorful Swirl

Brookside Gardens, Wheaton, Maryland

Nikkor 80–200mm f/2.8 lens
81B multi-coated warming filter
f/22
Multiple exposures with zoom and rotation

This is one of the few tripod-mounted multiple exposures in this book. I used the tripod in order to get more precision in moving between the nine exposures and in placing the orange anchor point. Thus, the image contains many sharp edges that are not apparent in handheld multiples.

Instructions:

1. Set your camera up to shoot eight or nine exposures, three stops underexposed, on a single frame. This can be done manually or on aperture priority using exposure compensation at –3.

2. Take the first exposure, then rotate the camera slightly to the right or left. Zoom in a small bit, keeping your "hub" in a predetermined grid intersection on your grid screen.

3. Repeat for the remaining exposures, repositioning the target flower in your grid each time.

4. Advance the film and take your camera off of multiple exposure mode and exposure compensation after making your multiples.

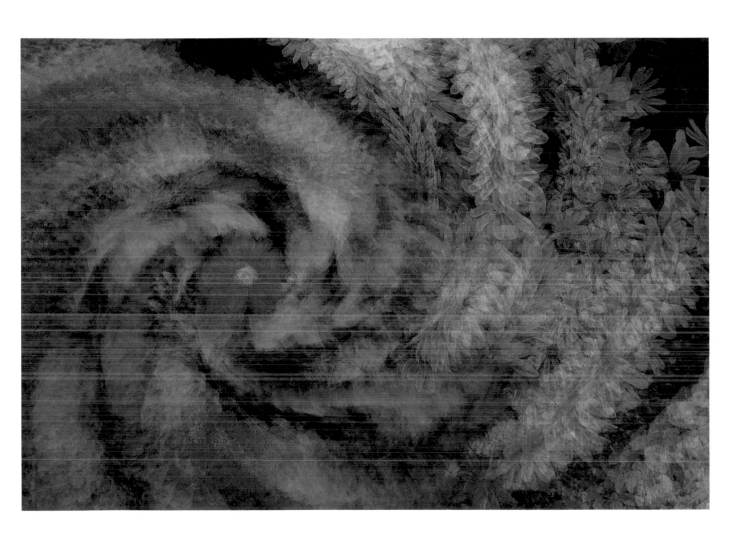

Lupin Field

Shamper's Bluff, Kingston, New Brunswick, Canada

Nikkor 80–200mm f/2.8 lens
81B multi-coated warming filter
Slide sandwich/montage

This image just caught the backlight on the front lupin, which is accentuated by the glowing effect of the slide sandwich technique. As before, this is a technique in which two separate images are made at different exposures and placed together in a single slide mount, with a "glow" or halo effect as the result. This is a high-contrast technique and should be made in diffused light or on a bright, overcast day, avoiding shadows as much as possible. For best results, use a telephoto lens in the 80–200 range and shoot a scene with average tonality.

Instructions:

1. Make the first image at f/22 and overexpose by two stops. This can be done manually or on aperture priority using exposure compensation at +2.

2. Make the second image at your widest aperture, overexpose by one stop, and defocus until the image blurs. The defocusing, in combination with the sharp +2 overexposure in Step 1, is what creates the appearance of a glow.

3. When you get the slides processed, unmount the two sandwich slides and remount them together in a GEPE glassless slide mount, Art. no. 7001.

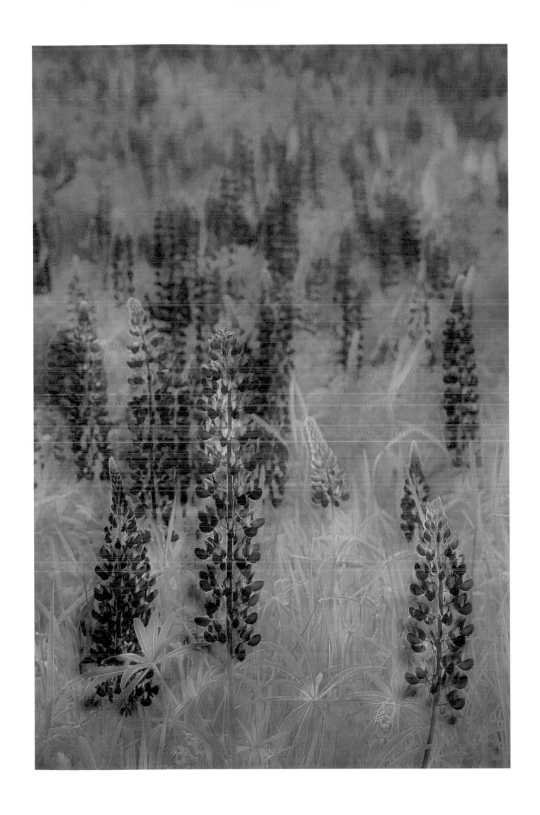

Oyster Plant

Sleeping Bear Dunes National Seashore, Michigan

Micro-Nikkor 105mm f/2.8 lens
1.4X teleconverter
Nikon 4T close up diopter
81B multi-coated warming filter
f/11

There is great depth within this flower. Oyster plants contain many small, orb-like flowers that are similar to dandelions, but much larger. As this image shows, high magnification can transform a close-up image into a vast, abstract macro-landscape. The out-of-focus orbs seem to flow through the picture while framing the three sharp points at the top center. Depth of field is almost nonexistent at very high magnification, and shooting wide open, without critical focus, will render a soft image with no discernable point of sharpness. Using f/11 only minimally increased the depth of field in this picture, but it was enough to sharpen the several points of focus at the top while leaving the remainder completely out of focus.

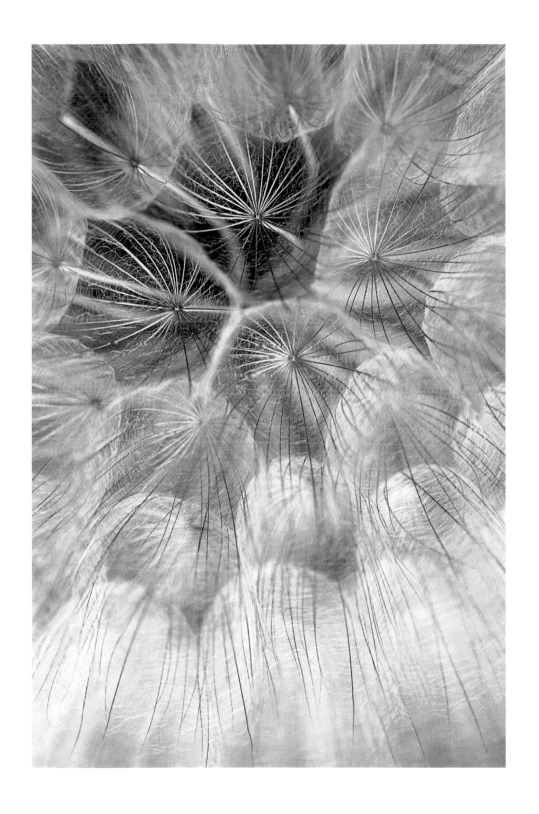

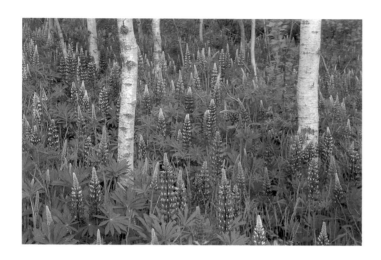

Lupin Patch and Birch Trees

Acadia National Park, Maine

Nikkor 35–70mm f/2.8 lens
81B multi-coated warming filter
f/16
Multiple exposures with vertical movement

Being able to previsualize an abstraction comes from shooting a lot of them. There are no shortcuts. The vertical nature of the lupin and birch trees made this an easy choice for the multiple-exposure technique. Moving the camera up and down between the eight exposures elongated the birch and lupin lines and softened the greens, creating a supportive background. Notice how the camera movements cover the "black holes" at the back of the image. Since these images are rarely repeatable, it's always a good practice to shoot at least five versions of each multiple exposure.

Instructions:

1. Set your camera up to shoot eight or nine exposures, three stops underexposed, on a single frame. This can be done manually or on aperture priority using exposure compensation at –3.

2. Take the first exposure, then move the camera slightly up or down.

3. Repeat for the remaining exposures, moving the camera a short distance after each shot.

4. Advance the film and take your camera off of multiple exposure mode and exposure compensation after making your multiples.

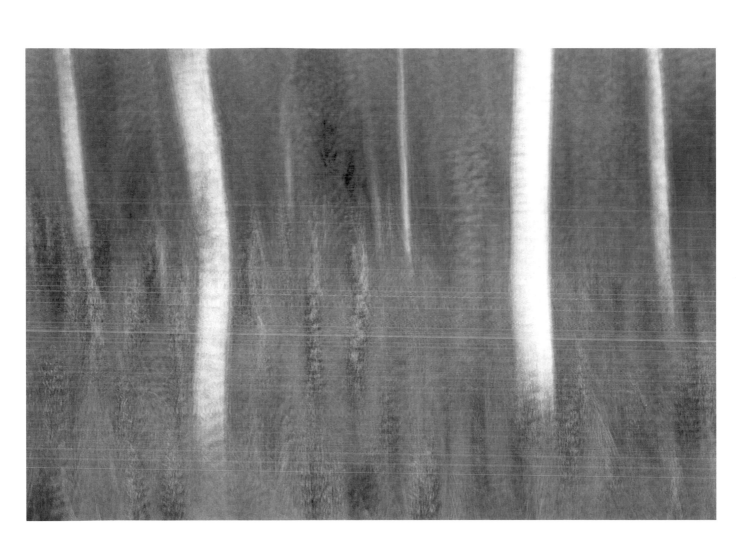

Red Against Blue

Cilburn Park, Baltimore, Maryland

Nikkor 300mm f/4 lens w/14mm extension tube
81B multi-coated warming filter
f/4

I chose this subject for the contrast between the red zinnia and the blue salvia and green leaves in the background. Using a 300mm lens with an extension tube sufficiently softened the background and blended the colors. I was careful to place the zinnia in the only light green area in the image space for maximum color contrast. Notice that the flower center is not in the middle of the frame but closer to the bottom. With a few exceptions (see page 44), placing a subject in the middle of the frame (the "bull's-eye") makes for static composition.

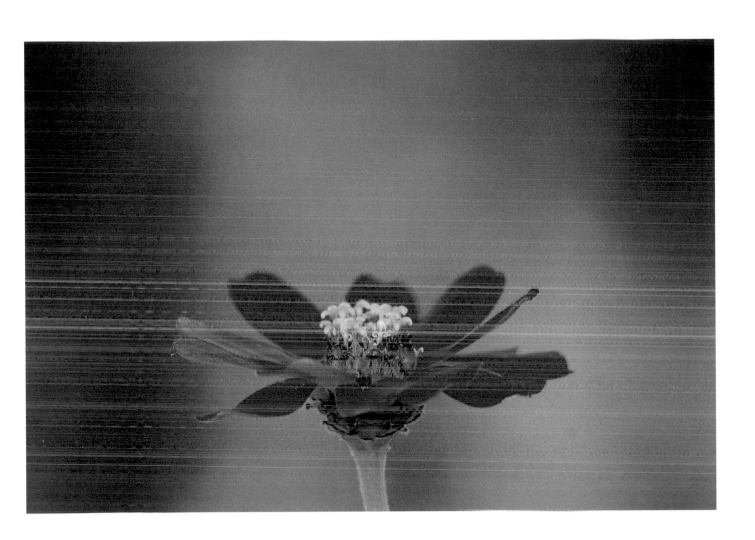

Poppy Repetition

Olney, Maryland

Nikkor 300mm f/4 lens w/14mm extension tube
81B multi-coated warming filter
f/8

This is a repeating pattern of poppies. After viewing different depths of field with the depth-of-field preview button, I decided to use f/8 in order to show some detail in the background poppy. I adjusted the camera height in order to get the background poppy to appear to be rising out of the sea of muted red. When shooting close-ups at somewhat shallow depths of field like f/8, point of focus is important. The main point of focus in this image is the center of the foreground pink poppy; I let everything else go soft for visual contrast and to further attract attention to the foreground.

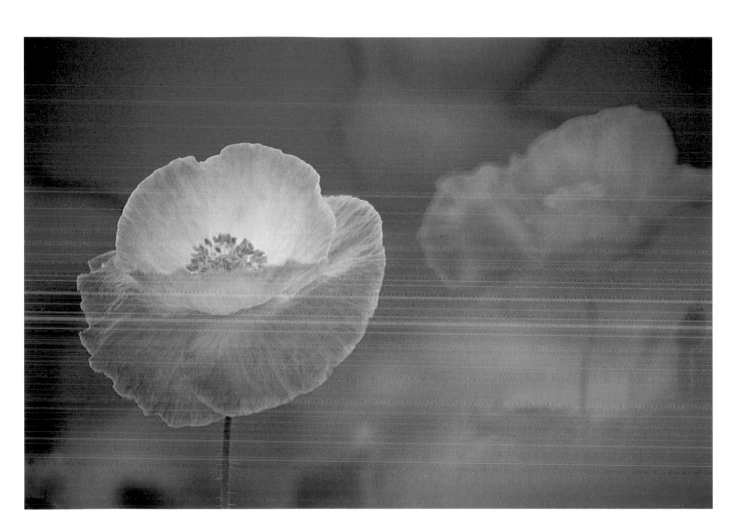

I think the best pictures are often on the edges of any situation. I don't find photographing the situation nearly as interesting as photographing the edges.

—William Albert Allard

B. W. Orbs

Brookside Gardens, Wheaton, Maryland

Nikkor 300mm f/4 lens
81B multi-coated warming filter
f/4

A friend of mine started shooting this scene as I was leaving. Upon looking through her finder, I quickly began shooting a similar subject in the same area. This image shows the sun strongly backlighting a dewy subject and is remarkable in its openness. The flower is in the beginning of its bloom, with only the stalks present, upon which it will grow. When I returned the following week, this scene didn't exist: the flower had filled in the lines, which were no longer visible. Because the sunlight was getting hotter and changing angle by the minute, I only had a few minutes to get this image. I placed the hub in the upper left third of the frame, with the lines and specular highlights radiating outward. These highlights are a direct result of shooting at the widest, and therefore roundest, aperture. A nice fringe benefit of shooting into bright sun is that it can create rainbows, like the one in the bottom center of the frame.

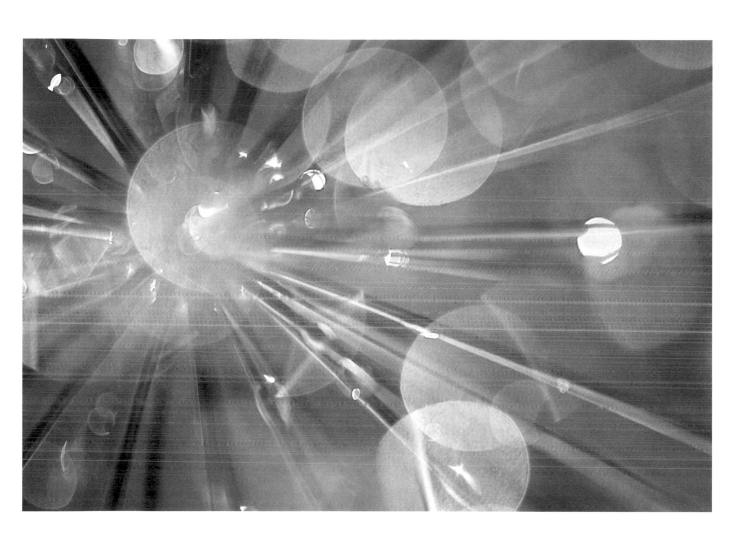

Salvia

Sherwood Gardens, Baltimore, Maryland

Nikkor 300mm f/4 lens
81B multi-coated warming filter
f/5.6
Multiple exposures with loosened tripod collar

The image at the top of this page is a straight shot using fill flash at −1.7 power. The light was behind the subject and the flash filled in some shadow areas.

The Nikkor 300mm f/4 has a tripod collar. The larger image was made by gently twisting the camera back and forth on its loosened collar between each of the eight exposures. Normally, on this type of multiple, you would notice some detail in the background. The softness of the background in this image is a function of camera position and the wide aperture. By lowering the tripod so that its legs were spread flat on the ground, I changed the angle to the point that I was shooting straight into the salvia. The background is muted because of its distance behind the subject and the shallow depth of field.

Instructions:

1. Set your camera up to shoot eight or nine exposures at −3. Loosen the camera's tripod collar.

2. Take the first exposure, then gently twist the camera in one direction.

3. Repeat for the remaining exposures, twisting the camera back and forth in small increments between each shot.

4. Advance the film and take your camera off of multiple exposure mode and exposure compensation after making your multiples.

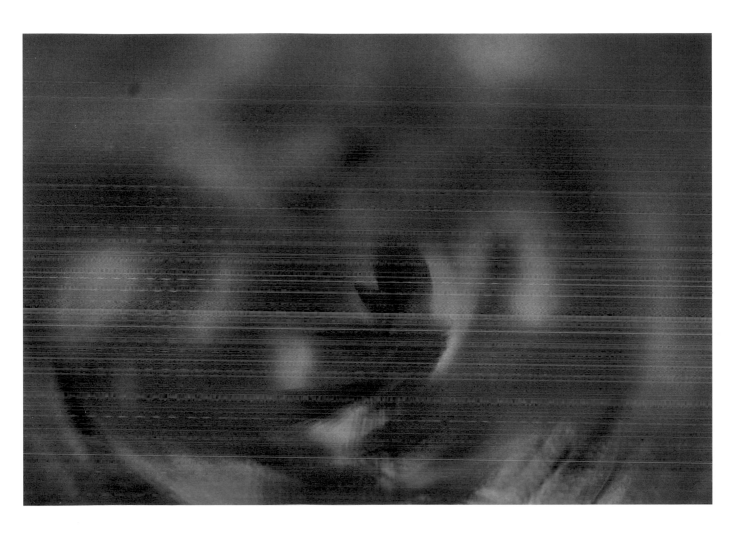

Daisy and Red Bulbs

Easton, Maryland

Nikkor 300mm f/4 lens
81B multi-coated warming filter
f/4

In general, bright and colorful images are more successful in the marketplace. It's a good idea, especially with flowers, to include as much color as possible. Using a shallow depth of field can create, as in this image, soft pastel tonalities. The soft background also contrasts with the brighter colors and sharper focus of the daisy. Placing the daisy at the extreme bottom third of the frame gives the eye an area upon which to rest, yet it allows the viewer to visually explore the background without distraction.

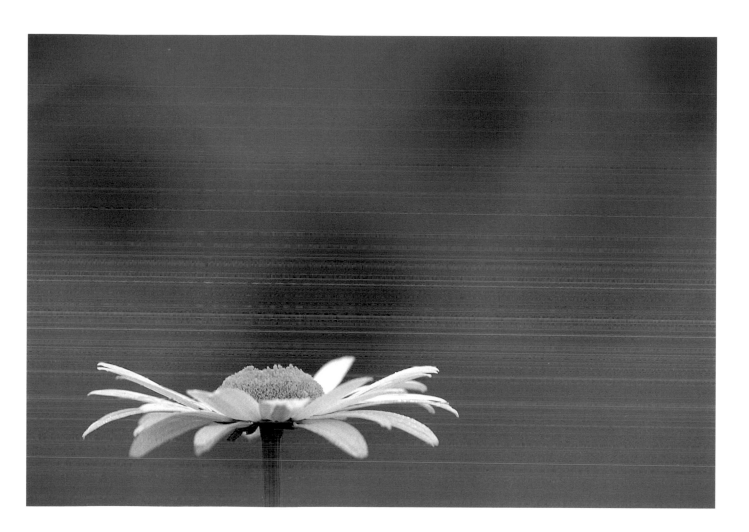

Poppy and Daisy Frame

Easton, Maryland

Nikkor 300mm f/4 lens
81B multi-coated warming filter
f/4

This image is the exact opposite of the previous one. In this case, the lens is focused through the foreground daisies to the red poppy. When using shallow depth of field, extreme care should be taken with the point of focus. If the intended point of focus is off by a hair, the image fails. In this picture, the camera is right up next to the daisies for maximum blur and positioned to place the poppy in a green, detail-less background.

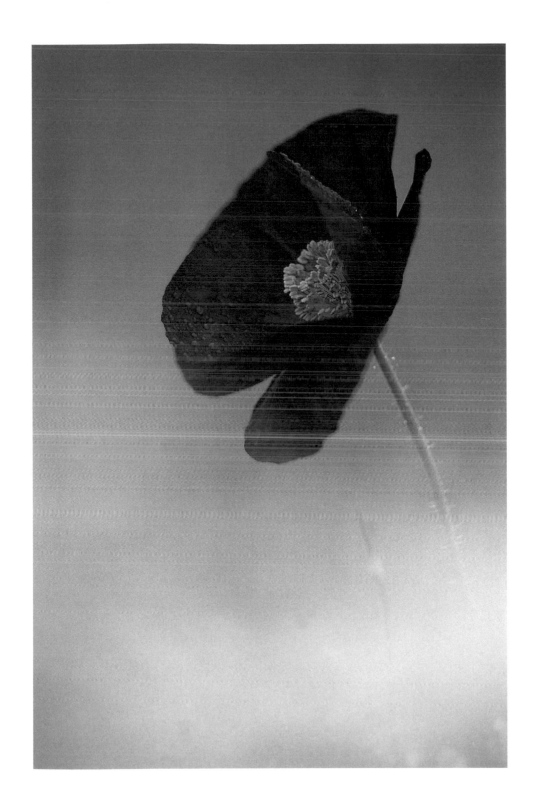

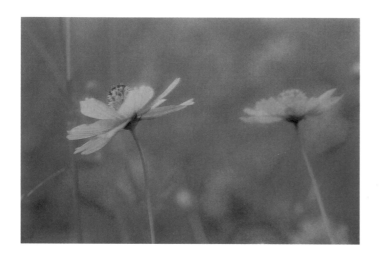

Soft Coreopsis Duo

Sherwood Gardens, Baltimore, Maryland

Nikkor 300mm f/4 lens w/14mm extension tube
81B multi-coated warming filter
f/4
Triple exposure

The smaller image above is a double exposure with the first exposure at f/22 and the second one wide open and slightly defocused. This succeeds in drawing the viewer's attention to the foreground flower despite a somewhat busy background. Each exposure was shot one stop underexposed.

The larger image is a triple exposure. All three exposures were shot wide open at f/4. This technique achieves sharpness with both flowers while almost completely blurring the background. Rather than going to −1 as in the double exposure, go to between −1.3 and −1.7 for each shot of the triple exposure. I shot this on Nikon matrix metering with exposure compensation at −1.3. The halos around the flowers are the result of focusing on them with the shot wide open. The difference made by adding the third, fully defocused exposure becomes apparent by comparing the backgrounds of the two examples.

Instructions:

1. Set your camera up to shoot three exposures on a single frame. Exposure compensation should be −1.3 for a slightly brighter exposure and −1.7 for a slightly darker exposure.

2. Shoot the three exposures wide open, with the camera in the same position each time. In the image on the right, the first exposure focused on the center of the front left flower, the second focused on the center of the back right flower, and the last was completely defocused.

3. Advance the film and take your camera off of multiple exposure mode and exposure compensation after making your multiples.

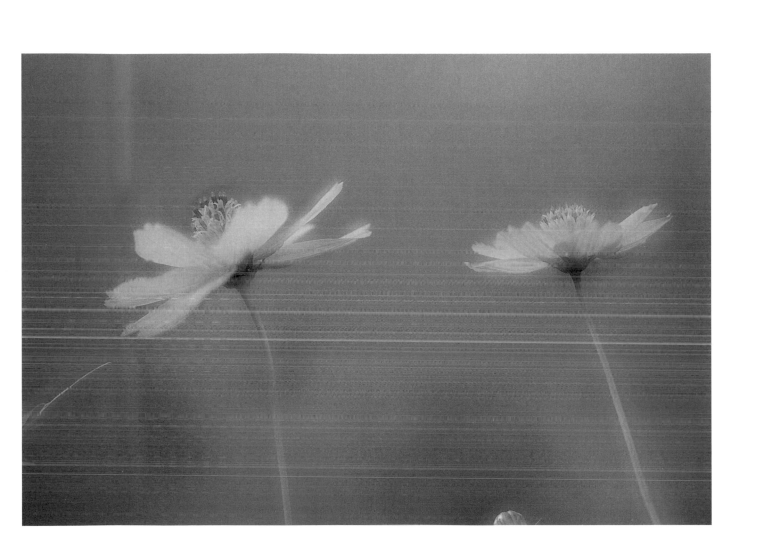

Water Lily

Holt Park, Baltimore, Maryland

Nikkor 300mm f/4 lens w/ 20mm extension tube
1.4X teleconverter
B+W 81A warming filter
f/16

Aside from the small black speck in the center, this water lily was incredibly pristine. Because it was in a pond, I could only get within about three feet of it. I had to position myself very carefully so that the diffused light "lit up" the flower—even moving a few inches to either side would have affected the brilliance of the light. I also strove for balance in this shot, placing the visual weight in the bottom center and spreading the petals throughout the frame. For a picture such as this, it's usually a good idea to fill the frame with your subject.

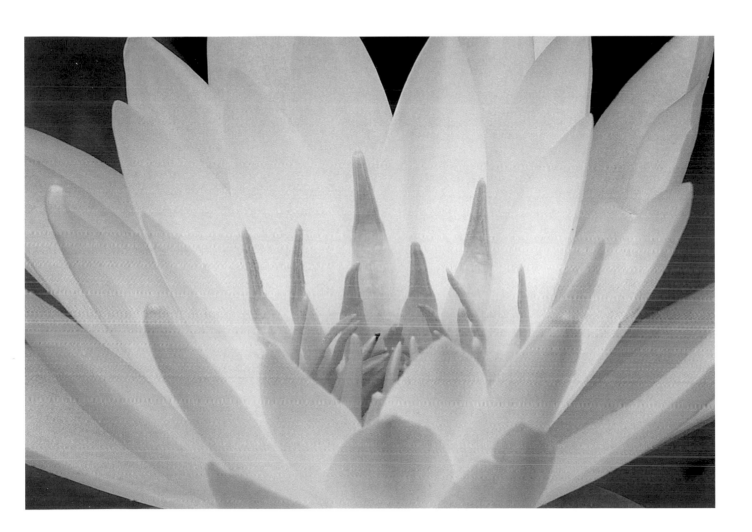

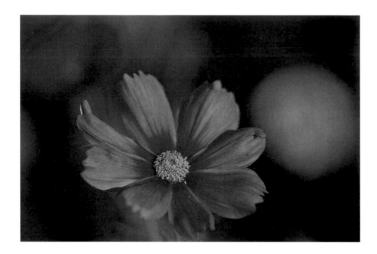

Pink Cosmos

Olney, Maryland

Nikkor 80–200mm f/2.8 lens
81B multi-coated warming filter
f/5.6

These examples illustrate the difference between shooting with a diffusion disk (facing page) and without one (above). Notice the high contrast in the smaller image: there are both patchy, dark areas and bright, blown-out ones, which is indicative of direct sunlight on a subject. In the main image, the light is diffuse, leading to an evenly lit scene with no harsh contrast. Of particular note is the yellow flower on the right of the image. In the smaller picture, the bright sunlight striking the flower also creates the dark background behind it. In the main image, the yellow flower is only barely visible. Overall, the main image is softer, has richer color, and is easier to view.

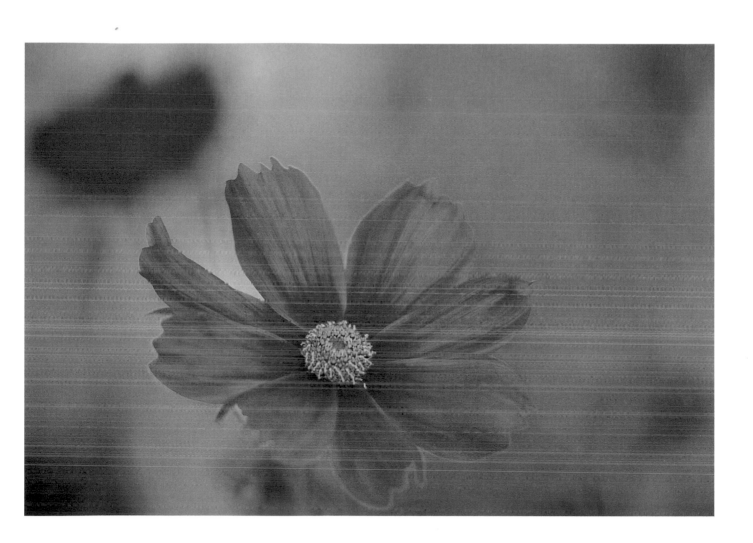

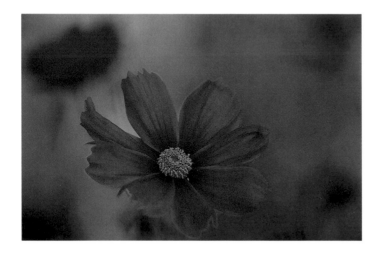

Pink Cosmos Double

Olney, Maryland

Nikkor 80–200mm f/2.8 lens
81B multi-coated warming filter
f/2.8
Double exposure

The image above is the image on page 93, shot in bright sun with a diffusion disk to hold back the light. The image to the right is the same scene, rendered quite differently.

Normally, a double exposure is shot with each exposure underexposed by –I in order to achieve the metered, or "correct," exposure. In this case, my compensation was +1 for each exposure, resulting in a two-stop overexposure. One has total latitude in interpreting and brightening or darkening an image. The final result can be quite dramatic and wonderfully unusual and unique. The overexposure here created an uplifting feeling and sings of summer! The first exposure focused on the foreground poppy center, while the second exposure focused on the center of the purple poppy in the background. The shallow depth of field of each exposure added to the soft, muted quality of the final image.

Instructions:

1. Set your camera up to shoot two exposures on a single frame. Exposure compensation should be set at +1.

2. Shoot both exposures, keeping the camera in the same position. The exposures should each have a different element as the point of focus.

3. Advance the film and take your camera off of multiple exposure mode and exposure compensation after making your multiples.

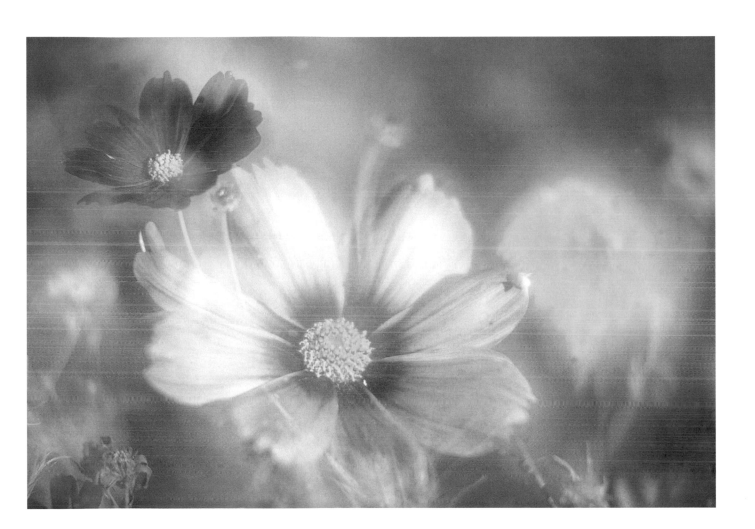

Red Frame

Sherwood Gardens, Baltimore, Maryland

Nikkor 300mm f/4 lens
81B multi-coated warming filter
f/4

This image incorporates two design elements: repetiton and framing inside the frame. The repetition between the large foreground and small background flowers is obvious. As for framing, I saw the opportunity to create a red frame around the foreground subject and just kept moving around, repositioning the camera until I found the composition that I imagined. This frame consists of two peonies, side by side. By placing their leaves almost right up against the lens and focusing past them at my widest aperture, I created the translucent red frame that you see here caressing the subject.

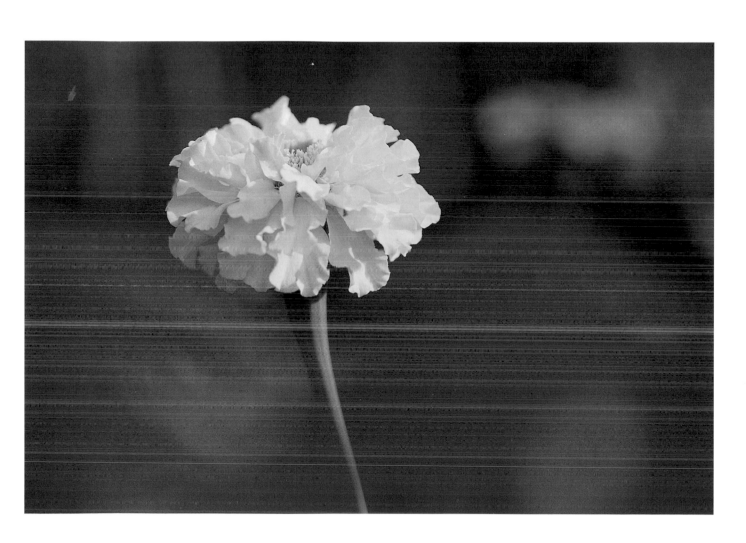

Waterlily Twirl

Longwood Gardens, Kennett Square, Pennsylvania

Nikkor 300mm f/4 lens
f/22
Multiple exposures with loosened tripod collar

This image was selected for the pristine nature of the flower and the black, opaque color of the pond in the background. Notice how the colors pop against the black background. While leaving the camera on the tripod, I made eight exposures on one piece of film while twisting the camera back and forth in very small increments between each exposure. The center of the flower is the point of focus and is sharper than the rest of the picture because it is close to the hub around which I rotated the camera. The flower center was placed at the bottom center of the frame for visual weight.

Instructions:

1. Set your camera up to shoot eight or nine exposures at −3. Loosen the camera's tripod collar.

2. Take the first exposure, then gently twist the camera in one direction.

3. Repeat for the remaining exposures, twisting the camera back and forth in small increments between each shot.

4. Advance the film and take your camera off of multiple exposure mode and exposure compensation after making your multiples.

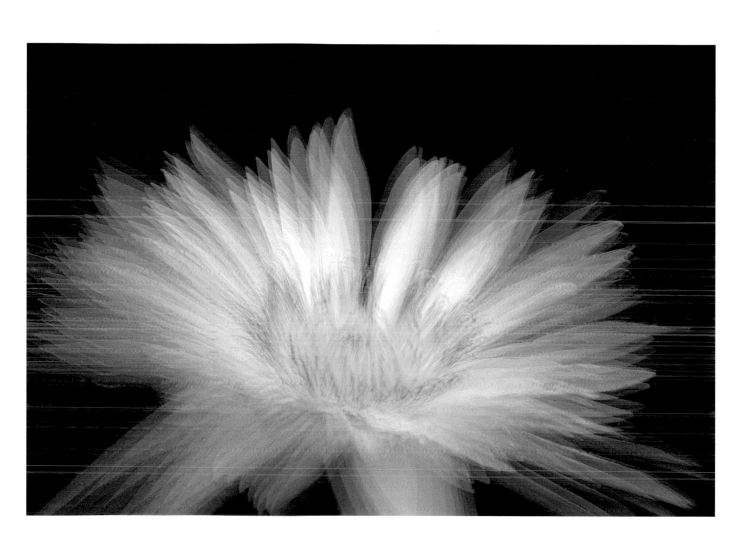

My best work is often almost unconscious and occurs ahead of my ability to understand it.

—Sam Abell

Tulips

Sherwood Gardens, Baltimore, Maryland

Nikkor 300mm f/4 lens
Singh Ray red intensifying filter
f/4

Tulip time in any location is a great time for photography: the possible color combinations are endless. On this image the 300mm, f/4 lens was used at its widest aperture for shallow depth and a blended, muted background. The red area consists of red tulips about 20 feet beyond the point of focus. Three green stems are placed in the center of the frame with the most prominent and sharpest stem in the area of deepest red for maximum color contrast. Situations like this are also great for using the Singh Ray red intensifying filter, as it deepens the reds and gives a gold tone to the yellows.

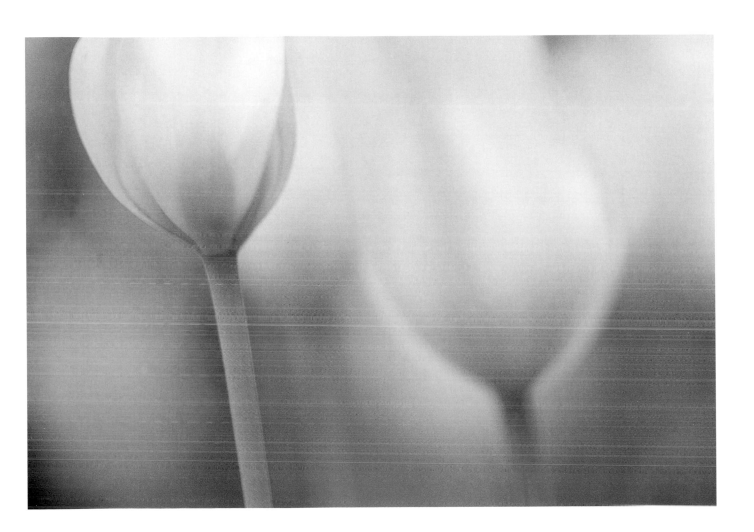

Colorful Abstract

Longwood Gardens, Kennett Square, Pennsylvania

Nikkor 35–70mm f/2.8 lens
Singh Ray red intensifying filter
f/22
Multiple exposures with vertical movement

As before, this image was created by moving the camera in short up-and-down movements between each exposure. The color contrast of red, maroon, and green was the attraction here. The camera movements, the multiple exposures, the bright sunlight, and the Singh Ray intensifying filter combined to create these pure abstract colors and intensify the contrast between the reds and greens. Shooting at f/22 kept detail in the scene even though the camera was being gently shaken.

Instructions:

1. Set your camera up to shoot eight or nine exposures, three stops underexposed, on a single frame. This can be done manually or on aperture priority using exposure compensation at −3.

2. Take the first exposure, then move the camera slightly up or down.

3. Repeat for the remaining exposures, moving the camera a short distance after each shot.

4. Advance the film and take your camera off of multiple exposure mode and exposure compensation after making your multiples.

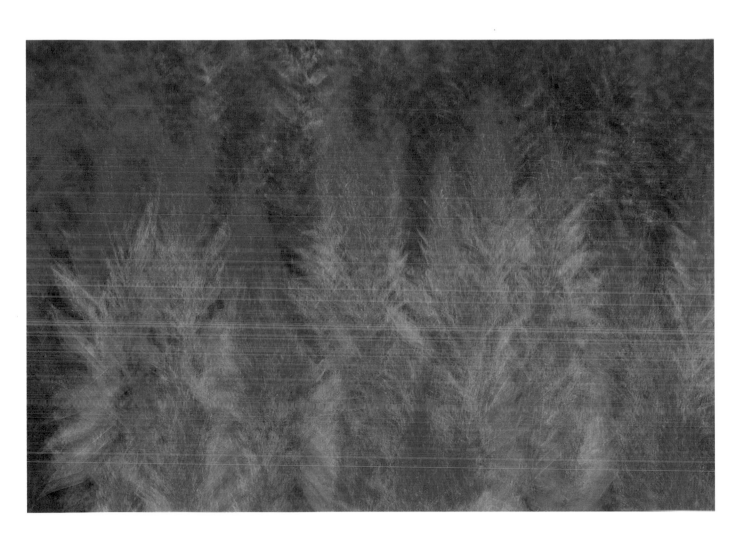

Seeing simply is seeing significantly.
 —Jack Wilkinson

Soft Sunflower

Bucks County, Pennsylvania

Nikkor 300mm f/4 lens
81B multi-coated warming filter
Double exposure

The two exposures in this image were both shot one stop underexposed, which is the proper technique for getting an accurately exposed double exposure. The first image was shot at f/22 and the second one was shot wide open and defocused (notice the halo). This is similar to the slide sandwich/montage technique discussed earlier, but it involves only a single piece of film; the result is softer and less dramatic. What's worthy of note here is the background, which has some light, puffy clouds. Through defocusing, the clouds become a soft white against the light blue sky. The visual pull in this image comes from the sunflower leaning away from the center of the frame while the single leaf leans into it, which also creates some visual irony. The subject was backlit by the sun, and I used a gold reflector to add light to the face of the flower.

Instructions:

1 Set your camera up to shoot two exposures on a single frame. Exposure compensation should be set at –1.

2. Shoot the first exposure at f/22 and the second one completely defocused.

3. Advance the film and take your camera off of multiple exposure mode and exposure compensation after making your multiples.

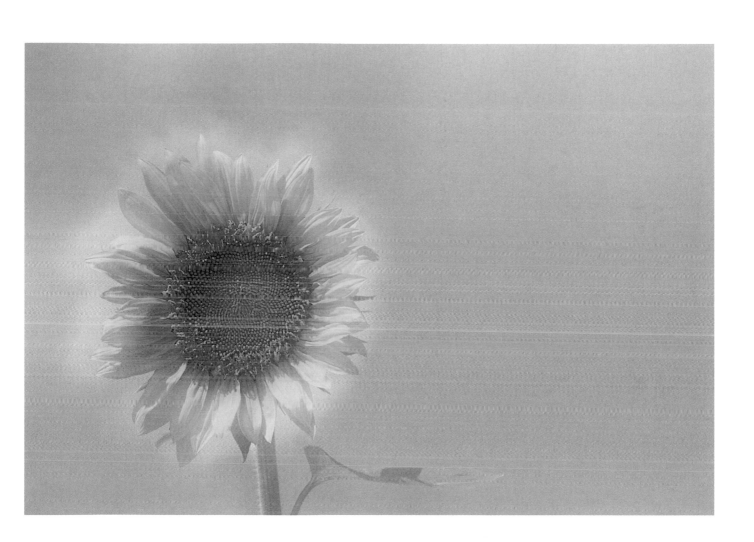

Equipment

Cameras

Nikon F5, F4 (http://www.nikonusa.com)

Fuji S2 digital camera with SanDisk
Extreme compact flash cards
(http://www.fujifilm.com;
http://www.sandisk.com)

Lenses

Nikkor 20–35mm f/2.8

Nikkor 35–70mm f/2.8

Nikkor 85mm macro tilt/shift f/2.8

Nikkor 80–200mm f/2.8

Nikkor 300mm f/4

Micro-Nikkor 105mm f/2.8

Sigma 12–24mm f/4.5–5.6 wide-angle
zoom (http://www.sigmaphoto.com)

Hasselblad XPan 30mm, 45mm, and 90mm

Attachments

Canon 500D diopter

Sigma 1.4x and 2x teleconverters

Nikon 8mm, 14mm, 27.5mm, and 52.5mm
extension tubes

Nikon SB-80DX flash

Filters

B+W 81A, 81B, 81C, and 81EF warming

Nikon Polarizer

Tiffen 812 (http://www.tiffen.com)

Hoya FL-D and FL-W

Singh Ray 10cc Magenta
(http://www.singhray.com)

Singh Ray fog

Singh Ray diffusion

Singh Ray red and color intensifiers

Singh Ray warm and blue/gold polarizers

Singh Ray 1-, 2-, 3-, and 4-stop graduated
neutral density

Singh Ray 2- and 4-stop graduated reverse

Tripods and Tripod Heads

Gitzo G1348 carbon fiber
(http://www.gitzo.com)

Arca Swiss B-1 ball head

RRS BH55 ball head
(http://www.reallyrightstuff.com)

Photo Bags

Lowepro Photo Trekker AWII
(http://www.lowepro.com)

Lowepro Dry Zone 200

Miscellaneous

Gossen Starlite light meter

Westscott 4-in-1 reflector and diffusor

The McClamp and the McStick: tools for
flower photography (http://www.tony
sweet.com/hotnewprod/mcclamp.html)

Digital Work Station

Macintosh G4 and G3 desktop computers

Macintosh G4 and G3 Powerbooks

Wacom Intuos 6x8 and 3x5 tablets
(http://www.wacom.com)

Microtek ArtixScan 120tf
(http://www.microtekusa.com)

Nikon Super Coolscan 4000 ED scanner

Epson Perception 3200 flatbed scanner
(http://www.epson.com)

Epson 7600 and 2200 inkjet printers

Silverfast scanning software
(http://www.silverfast.com)

Web Host: MacServe
(http://www.macserve.net)

Acknowledgments

I WOULD LIKE TO TAKE THIS OPPORTUNITY TO ACKNOWLEDGE THE MOST important people in my photographic and "real" lives, whose contributions are beyond measure:

Susan Milestone, quite simply the love of my life. I don't know how I survived this long without her. (She doesn't either.)

Mary and Emil Sweet, my parents, who gave me the gifts of passion and a relentless work ethic.

Kelly Gilmartin, my daughter, who has yet to realize how important she is to me.

Richard Roeder, whose template for integrity, creativity, generosity, and genius has guided me for over 25 years.

Michael Leventhal, close personal friend, fellow jazz musician, and sounding board for over 20 years.

Tony Gayhart, photography mentor, whose unselfishness in teaching and sharing photographic knowledge is an ever-present inspiration.

Pat O'Hara, one of the greatest visual artists of our time, personal mentor, and kindred spirit. His work and visual awareness are always on the tip of my photographic thoughts.

Jack Kennealy, digital guru, close personal friend, and shooting partner. One of Maine's very best photographers.

Gary Lloyd, who unselfishly introduced me to life-changing teaching and business opportunities.

Karen Hart, Hasselblad rep and good friend, who, by introducing me to the XPan and providing sage advice and generosity, has been instrumental in broadening my career.

Bryan Peterson, one of the world's top photographers, whose generosity and recommendations have gotten my work into one of the world's top stock agencies and onto the teaching staff of www.betterphoto.com.

Terri Ehrenfeld, to whom I am forever grateful for "low rent" office space when I was getting started. It was more helpful than she probably realizes.

Mark Allison and Stackpole Books, for giving me total creative freedom in publishing this work and *Fine Art Nature Photography*. The opportunities arising from these two projects are beyond calculation. Special thanks to my editor, Chris Chappell.

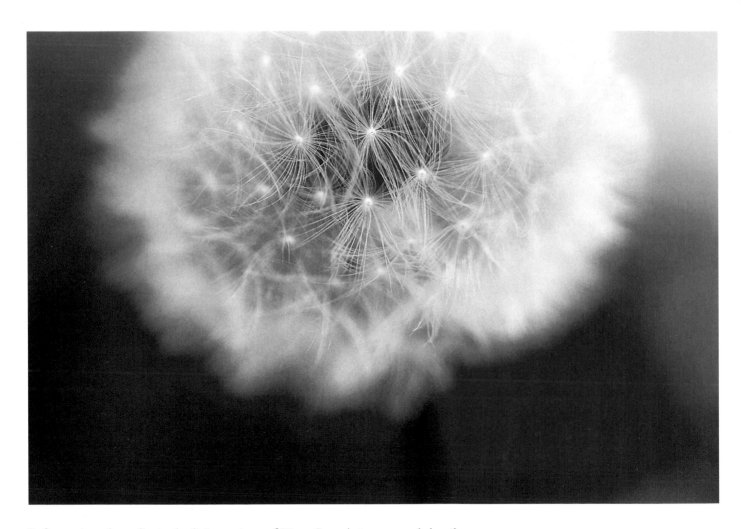

Information about limited edition prints of Tony Sweet's images and details about the photography workshops he offers are available on the author's website, www.tonysweet.com, or by e-mail at tony@tonysweet.com.